# Quantum Dreams

## THE ART OF STEPHAN MARTINIERE

Published by Design Studio Press
8577 Higuera Street
Culver City, CA 90232
http://www.designstudiopress.com
E-mail: Info@designstudiopress.com

Graphic design by Jane Ward
http://www.fancygraphics.net

Printed in Hong Kong
First Edition, August 2004

Softcover ISBN 0-9726676-7-9

# Foreword

**re·al·ize**, v.
To make real; to convert from the imaginary or fictitious into the actual; to bring into concrete existence.

This is the best word I can come up with to describe what Stephan Martiniere does. He is a bridge builder between the real and the imagined. He realizes people, places, and things that have only previously been understood and discussed precariously in abstract form.

I've had the pleasure of participating in the process of realization with Stephan – staring in wonder as he presents in tangible, believable, knowable form, what was previously only a whim or vague notion. It's a wonderful gift, this thing that he does so well; the first step in bringing fantastic worlds to life.

As you immerse yourself in the images in this book think of the thousands of words that preceded their creation: all of the work, all of the confusion, all of the difficulty in trying to understand and relate to only words and concepts. Stephan has taken all of these vagaries and realized something you can now simply bask in.

Sit back, relax and enjoy.

Rand Miller – creator of *Myst*

# Introduction

"When I grow up I want to be an astronaut!" These were my words at six years old in 1968. Space was the big thing at the time; it was one year before the first man walked on the moon. I held that wish of cumbersome space suits and blazing rockets as I started my schooling years. One grade after another I found myself drawing a lot, and the more I doodled, the more I liked it. This didn't alter my dream of becoming the next Neil Armstrong; I simply started to draw astronauts and rockets on paper.

I was born and raised in France. As a kid I was not allowed to watch much TV and the little I saw was in black and white. Like a moth who can't resist the light, I found myself drawn to the movie theatres, mesmerized by giant-sized pictures in Technicolor. A visual sponge, I became totally immersed watching Disney's animated films. As visions of cartoon characters riding rockets in cumbersome space suits were dancing in my head, I was increasingly drawn to the little movie theatre around my block. There, another and very different cast of characters began to entice my 10-year-old neurons. From the Werewolf to the Mummy, from Dracula to Frankenstein to King Kong, I traveled on the Voyage to the Center of the Earth and I experienced The Day the Earth Stood Still! The blood, guts and slime in all these classics were overwhelmingly cool!

The result was a gradual change in my drawings. My astronauts were now equipped with laser guns, battling monstrous alien ants that bore elongated fangs and razor sharp claws. Bambi and Cinderella quickly faded away (or maybe they were zapped or dismembered by alien monsters at the whim of my pencil). At the same time that this pandemonium of creatures was filling my dreams, my drawings also started showing strong influences of a super-heroic nature from the comic books I was reading. Superman, X-Men and all those bulging muscle heroes in colorful spandex were becoming part of my drawing fantasies. I started to appreciate the drawing skills involved, and was starting to emulate one style after another, as I discovered comic book masters like Jack Kirby and John Buscema. Being a big monster fan, Bernie Wrightson and his "Swamp Thing" became an important influence on my design as well.

My dream of becoming an astronaut started to fade away without regret. I realized my calling was going to be in art. My following years of junior high were booming times for the comic book industry; France was the happening place and I found myself bombarded by every style imaginable. At the same time that "Heavy Metal", the original Heavy Metal magazine was revolutionizing the comic book industry, I was discovering the book covers of Chris Foss. This wave of imagination and talents forever changed me. My astronauts, who had become super astronauts a while back, were now adorned with fanciful Arzak-like hats or piloting behemoth star ships. When high school started, I decided to specialize in art and was accepted to one of the renowned art schools in Paris. The following four years of learning solidified my desire to be a sci-fi fantasy comic book artist. I studied anatomy, perspective, advertising and architecture and a banquet of other areas. I found myself refining my skills and discovering new ones. The classical art and illustration masters became part of my daily sustenance, as did such landmark films as Alien, Blade Runner and The Dark Crystal. Completing my art school years, but unsure about making the jump to theprofessional comic book life, I found safety for a little while longer in an animation school. Bambi and Cinderella came back with a vengeance.

My expected two years in animation school were cut short when, unexpectedly, I was hired by an animation company as a character and background designer, at which point I was immediately sent to Japan. The next several years went by frantically, as I eagerly worked on a variety of projects, including Inspector Gadget and Ghostbusters. Comic books were put aside for a while as I found great joy and challenge at testing my skills all over the graphic spectrum of animation. As I traveled from Japan to California furthering my skills, I became more and more interested in the storytelling aspect of animation. I started working on animation storyboards, and eventually became a director for such television shows as Dennis the Menace, Madeline and Where's Waldo. One of the interesting aspects of directing is the idea of working with a team of people to achieve one vision, and to trust others to do their best to service a project. All that sounds very noble, and it did allow me to create some strong connections with many artists, but it also forced me to experience the convoluted meanders and the foul smell of office politics. Working in TV animation, where money and product endorsements talk, one's vision is not necessarily yours. The more I was forced to battle, duck, and finesse the on-going crises inevitable in any production, the more difficult it became to spend time drawing.

Several years and a lovely wife and a daughter later, I left the director's chair and came back to the drawing world. I started exploring new avenues in the theme park industry where I found great artistic excitement in creating whimsical and fantastic environments, which were then built in full scale. I started to realize how important it is for me to connect with an audience through my art. Theme parks led me to motion rides where I had another rewarding experience working on both Star Trek, the Experience and The Race for Atlantis in Las Vegas. Both of these projects were done in 3D and both had an irreversible impact on my career. Star Trek introduced me to Photoshop, which created a major shift in my career and later opened the gates of Hollywood. The Race for Atlantis allowed me to design almost an entire world, and see it created in full detail in high resolution 3D, projected on an IMax screen—and to top all that, to fly through it wearing 3D glasses! The sense of scale is incomparable. It was an unbelievably gratifying experience as an artist.  Not surprisingly, these two projects led me to special FX and Hollywood where I had the exciting oportunities to design for such films as Virus, Red Planet, I Robot and Star Wars Episodes 2 and 3.

Armed with some years of experience as a concept artist, the Photoshop palette, and a bit of 3D under my belt, I made my foray into the game industry working for Cyan, the company behind Myst. At the same time I started painting book covers. I loved both from the moment I started. In both fields I had the chance to work with people who appreciated and valued my artistic vision, trusted me, and allowed me to create fantastic worlds. I have also been very lucky to work with a talented group of people who have helped me to become a better artist along the way. Looking back at Chris Foss' cover and Myst's graphics has been yet another dream come true. I have been very fortunate. In the end, there is no greater joy than being able to do what you love and to know it is appreciated. It's a validation that gives meaning to your art and your life.

To my wife Linda and my daughter Madelynn who have been so supportive, understanding and patient all these years. Thank you for making me a better artist. Thank you for making me a better person.

# THE ART OF STEPHAN MARTINIERE

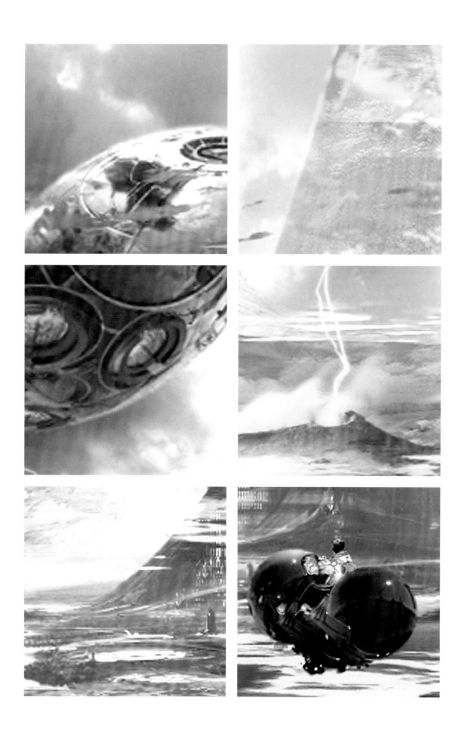

# RINGWORLD'S CHILDREN

**book cover** | written by Larry Niven

A sphere-shaped spaceship, miles in diameter, looms over the vast landscape of the Ringworld. The characters piloting their fly-cycles head for a mysterious dark mountain-shaped fortress.

What was important to me in this painting was to capture the sense of breathtaking wonder that I often experience when watching a movie, when the camera takes you over the edge of a mountain peak and the view suddenly opens up to a wide expense of land down below. Likewise in this painting, as the characters fly over a mountaintop, an immense landscape suddenly reveals itself.

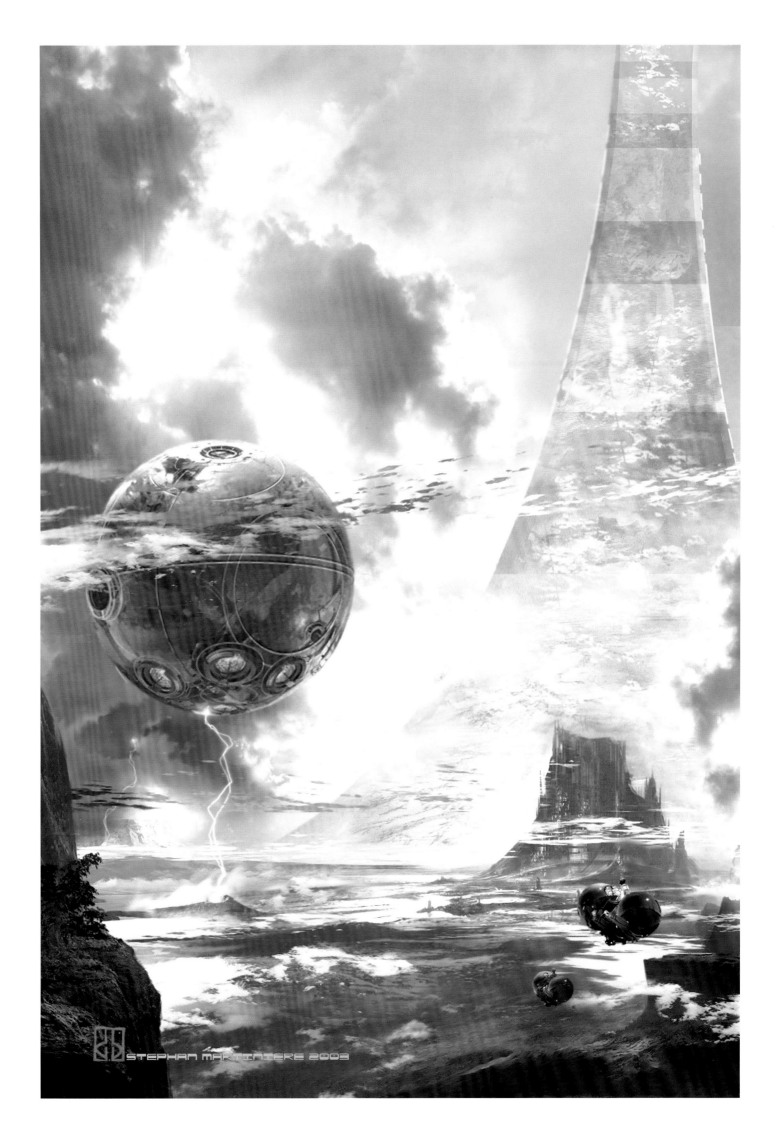

STEPHAN MARTINIERE 2003

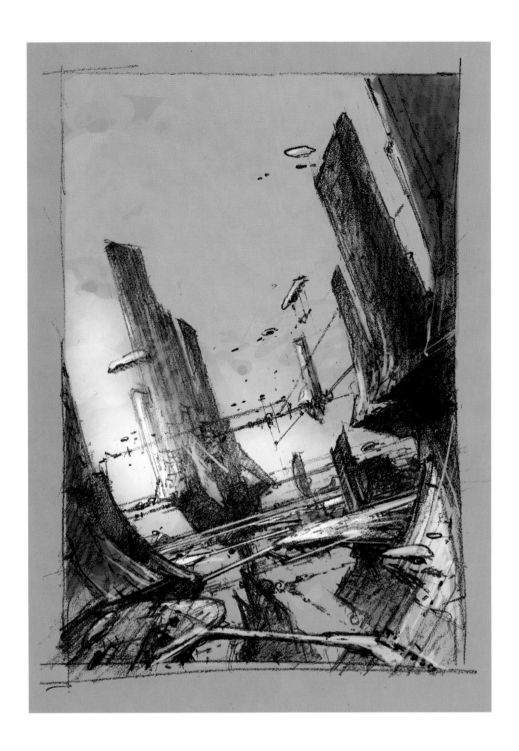

# TERRAFORMING THE EARTH

**book cover** | written by Jack Williamson

A millennium in the future, the Earth is entirely rebuilt.

This was my first book cover. The hole in the center and in the distance is what I think gives scale to the piece. It forces you to dive in and lose your footing. As my friend, Donato, nicely put it, "it messes with your brain."

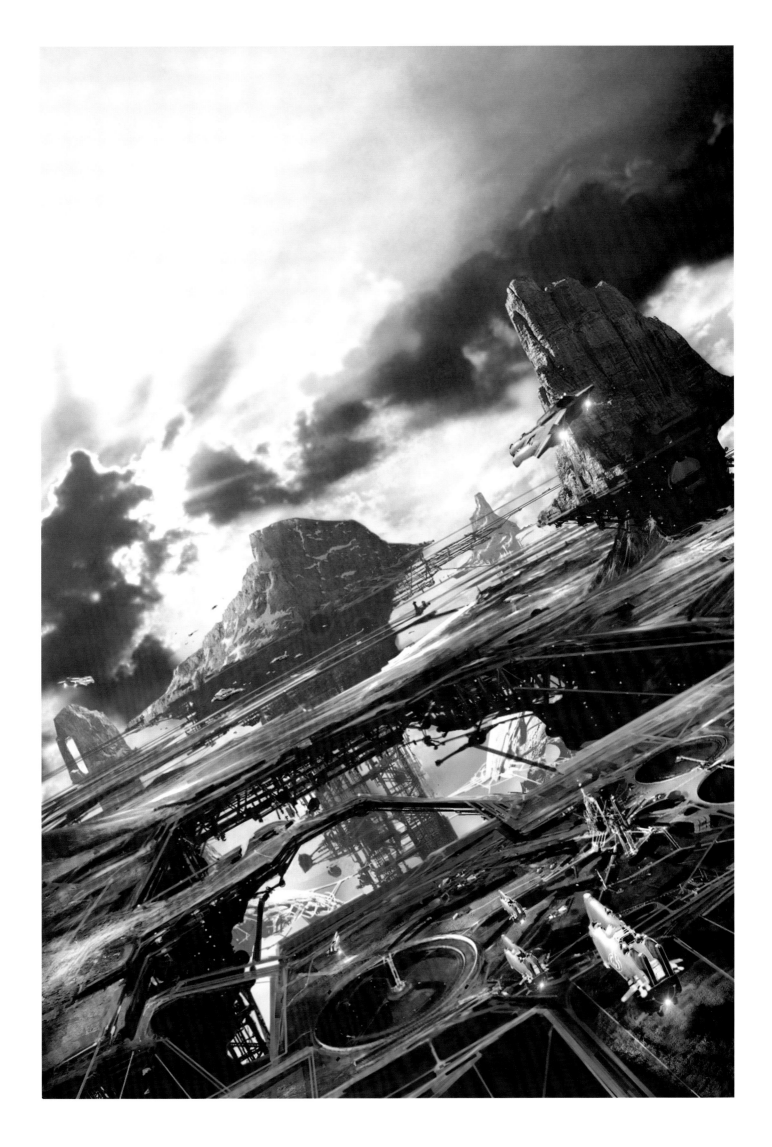

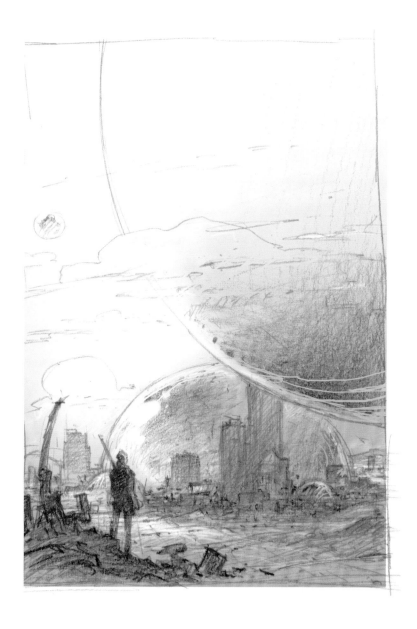

# THE PEACE WAR

**book cover** | written by Vernor Vinge

The peace authority conquers the world using a radical technology encasing military facilities, factories and entire cities in stasis inside silvery fields called "bobbles."

I wanted to paint a big blue sky with white clouds to convey the feeling of peace. The armed rebel walking toward the "bobbled" city is depicted in shadows to reinforce the idea of a secretive underground rebellion. I used KPT Bryce as the starting point for the bobbles. It's very simple yet very effective 3D software for creating reflections.

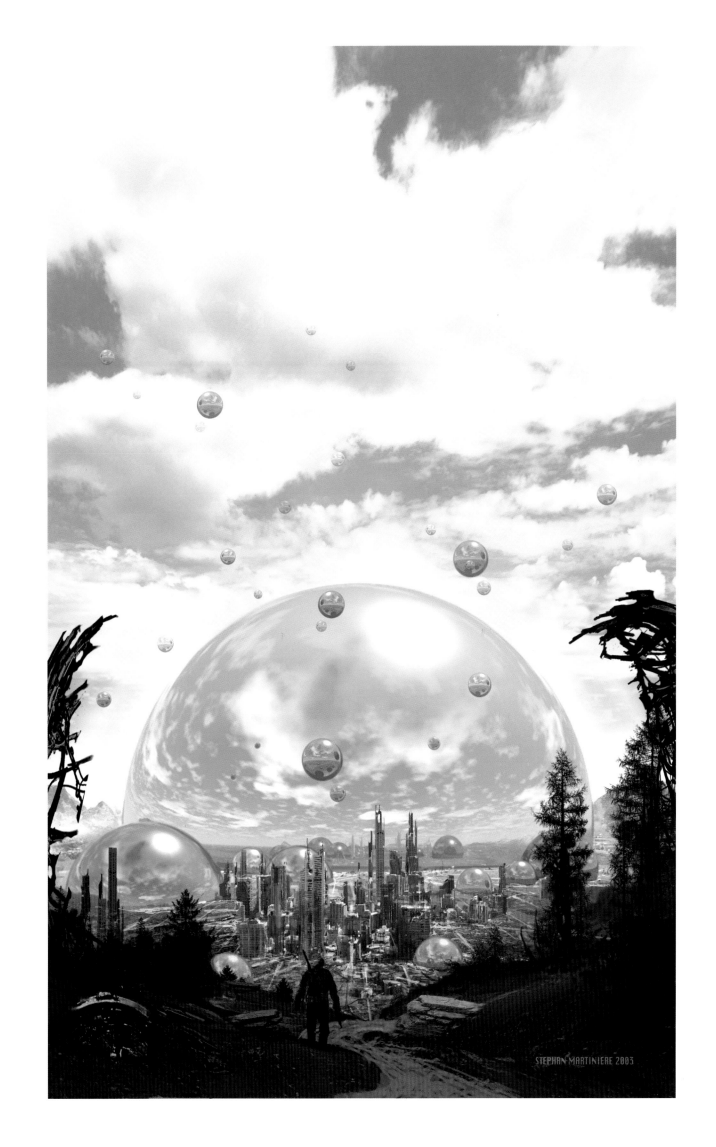
STEPHAN MARTINIERE 2003

# MAROONED IN REAL TIME

**book cover** | written by Vernor Vinge

The sequel to The Peace War. As a small human group "bobbles" itself and moves forward in time, one of the characters has been left behind, stranded in a wild environment.

I felt that a hazy sky with uses of green and gold colors would convey a sense of stillness. KPT Bryce came in handy again for this painting.

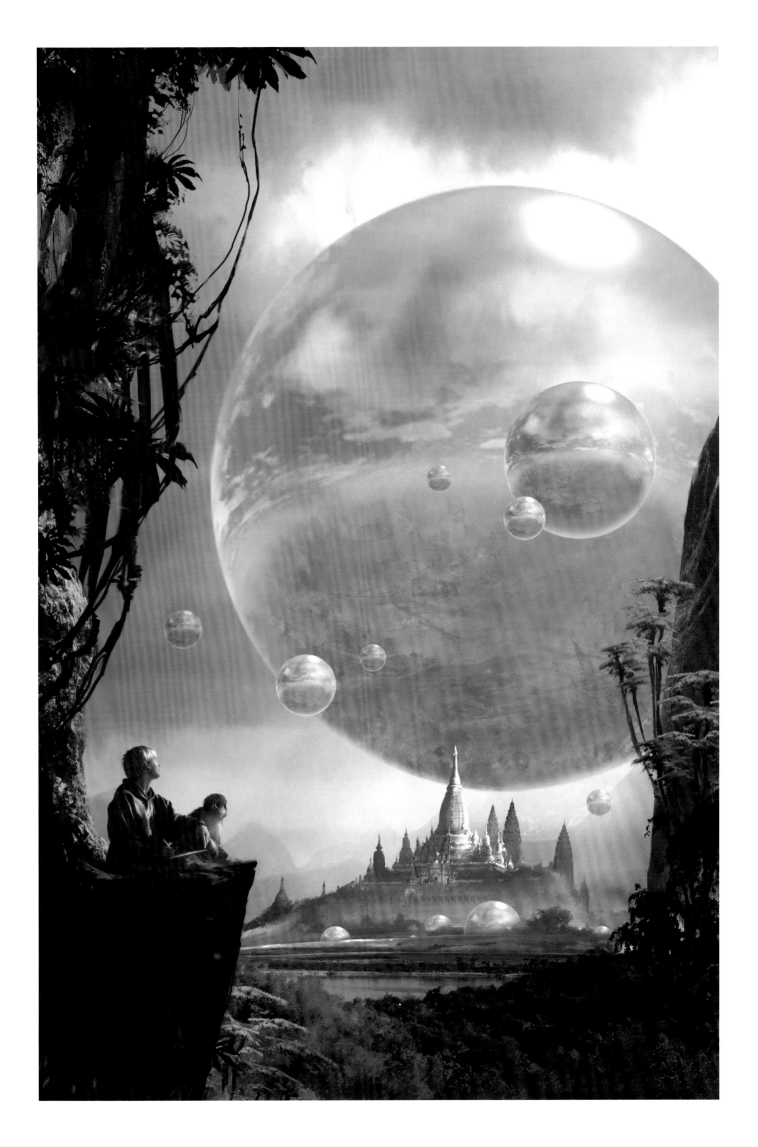

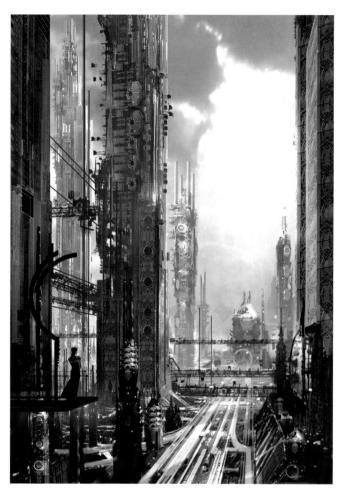

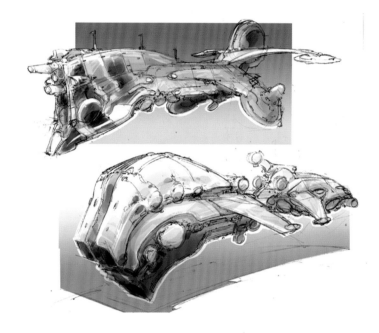

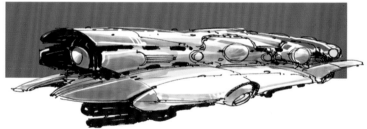

# ANGEL CITY

*Hitting The Skids In Pixel Town (top left)*

**personal painting** | later modified and used for the cover of *Hitting the Skids in Pixel Town*

This painting was my first attempt for the cover of Engine City. I didn't have the whole manuscript to read and in this rare instance I went way off subject! It was way too futuristic and too big in scale. The painting was put aside, unfinished, until a year or so later when I decided to finish it my way. I added spaceships and huge towers in the distance. The character surrounded by white doves, overlooking the city, was introduced to give some sense of scale but also to bring a contrasting feeling of magic and poetry. I particularly like the bottom part of the painting. The style is very graphic and impressionistic. It is a technique that I am using more and more.

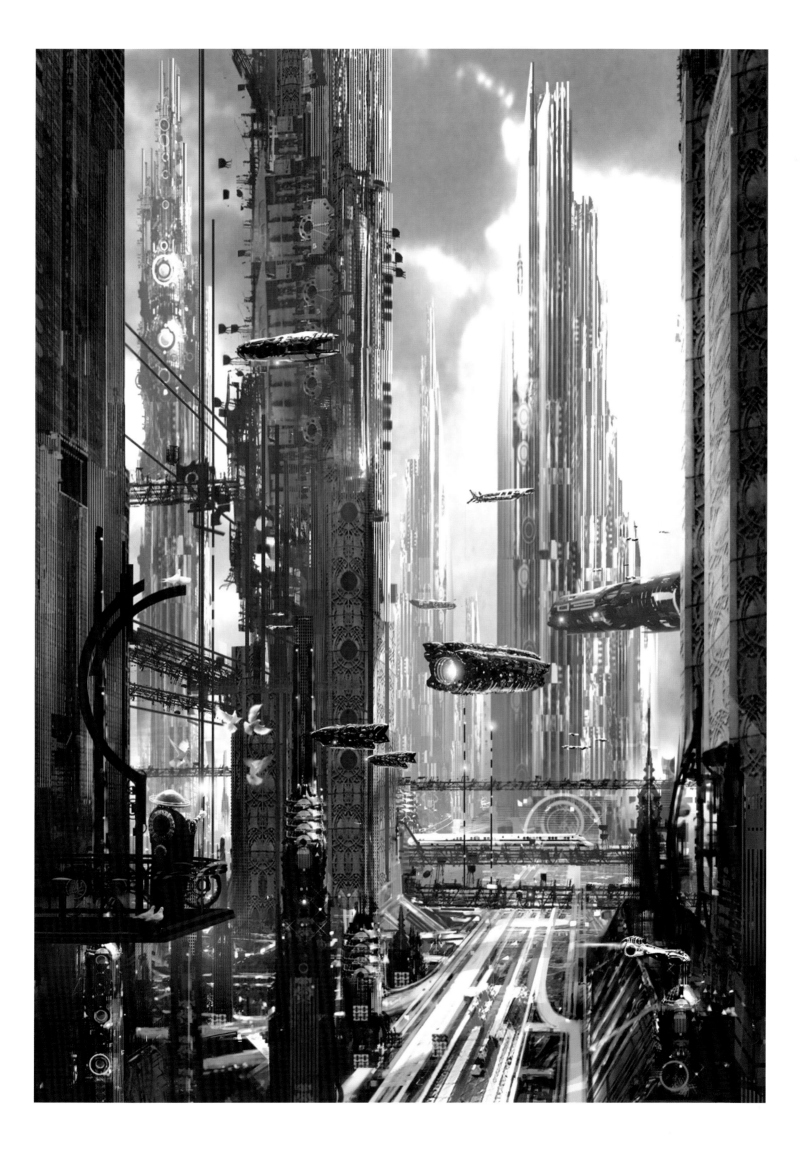

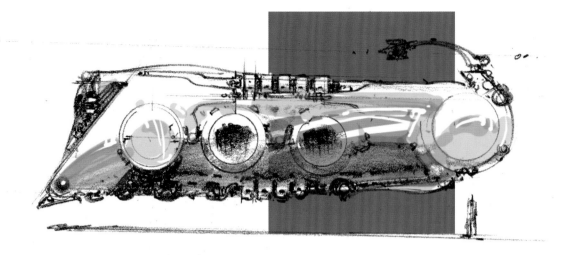

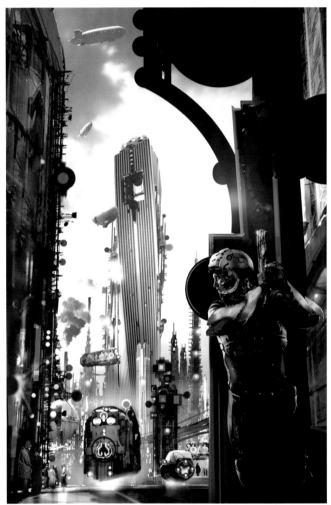

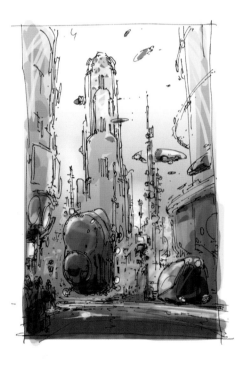

# ENGINE CITY (The Engines of Light, Book 3)

**book cover** | written by Ken MacLeod

A street view in the industrial district of New Babylon, a city at the beginning of industrialization. This painting was what the art director was originally looking for (see Angel City). I used a lot of dark tones, which seemed appropriate to convey the idea of drabness and pollution. It was important that the painting didn't look too futuristic, yet carried a feel of industrialization. The use of recognizable elements such as factory towers and smoke stacks seemed the right choice.

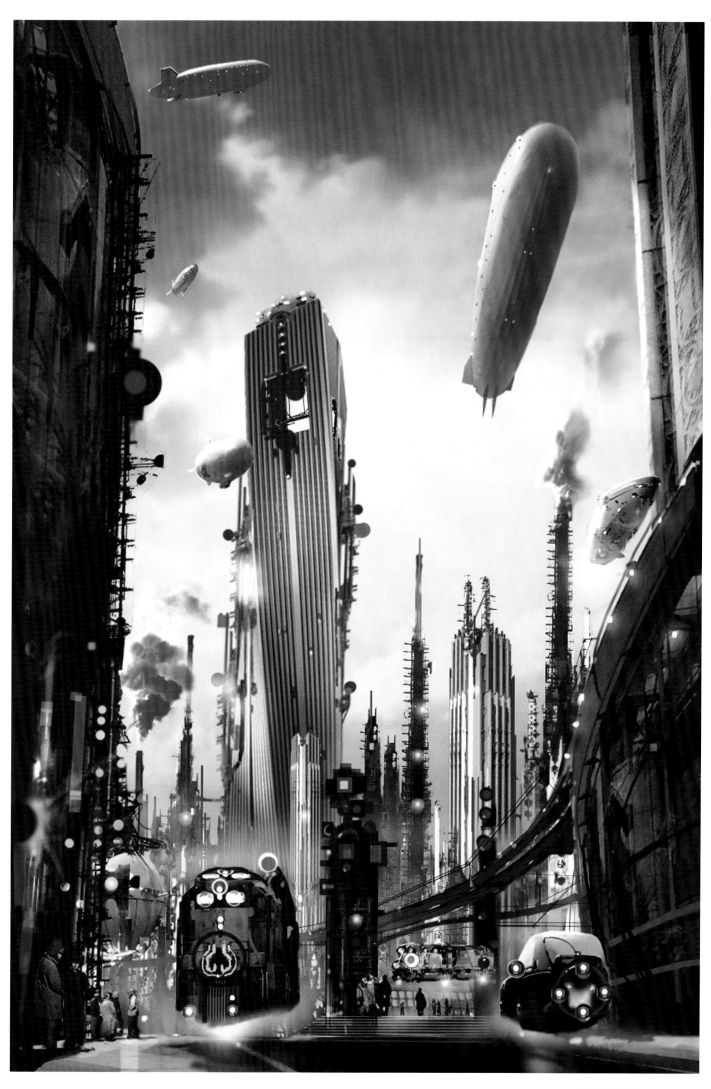

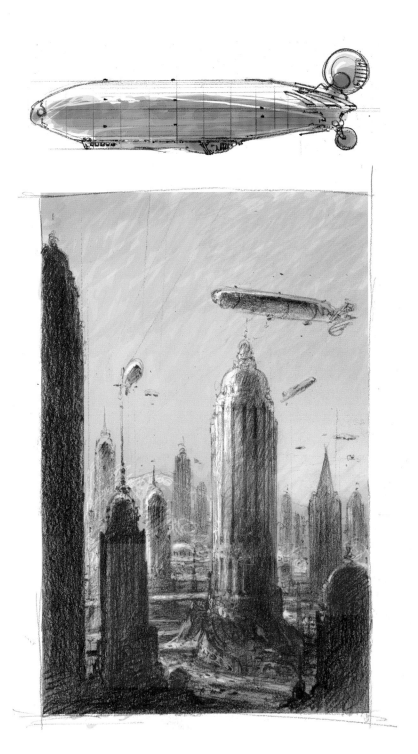

# THE AMERICAN ZONE

**book cover** | written by L Neil Smith

"The rendering is a means to an end; the end is architecture." Hugh Ferriss, 1940.

In an alternate America a dirigible slowly hovers above a version of Denver.

I have always admired the American Neoclassical Revival architecture and the Beaux-Arts tradition, such as the splendor of the Buffalo City Hall, the Chrysler building, and the majesty of such buildings as the New York Municipal Building and the Brooklyn Institute of Arts and Sciences, built by McKim, Mead and White. I also love the architectural vision of Hugh Ferriss' Metropolis. The American Zone was my attempt to create a Metropolis and explore these influences. I had to create a unique brush/stamp palette for many of the architectural elements.

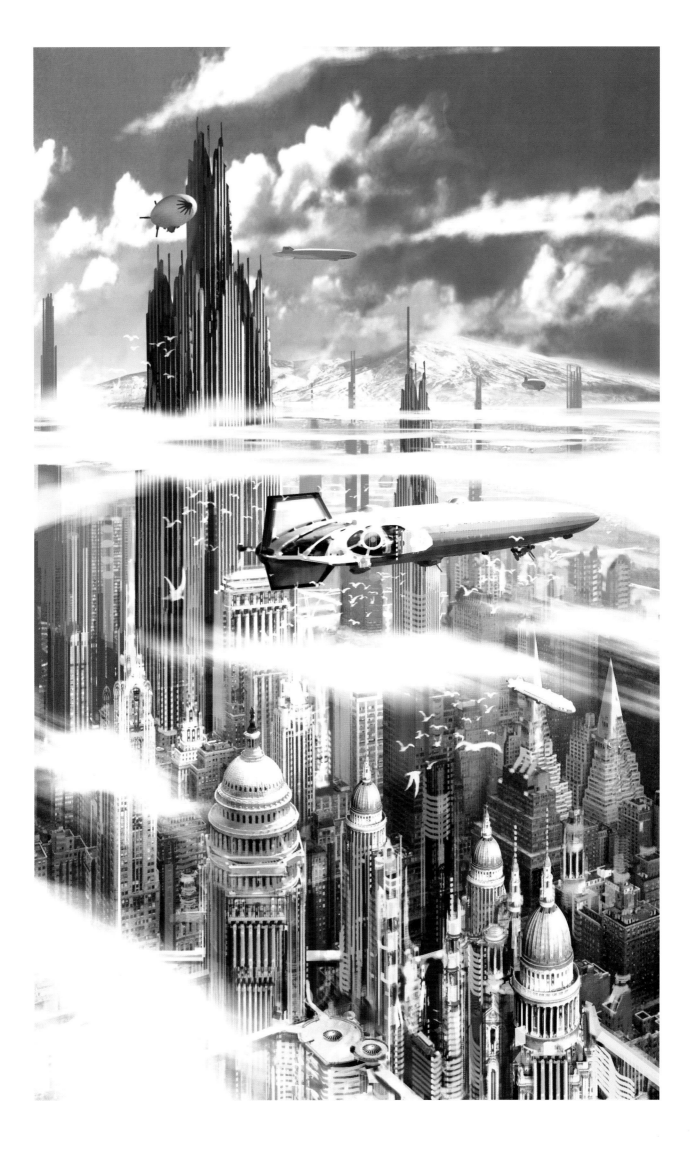

# THE GENESIS QUEST

personal painting | later purchased for the novel, *The Genesis Quest*, written by Donald Moffitt

That painting started during the production of the animated feature Titan A.E. The concept was for a city called New Bangkok located on a distant planet. Other ideas were proposed and my painting was put aside, unfinished. I completed it a few years later. I particularly like the lower section where the light hits the water, and the mood around it.

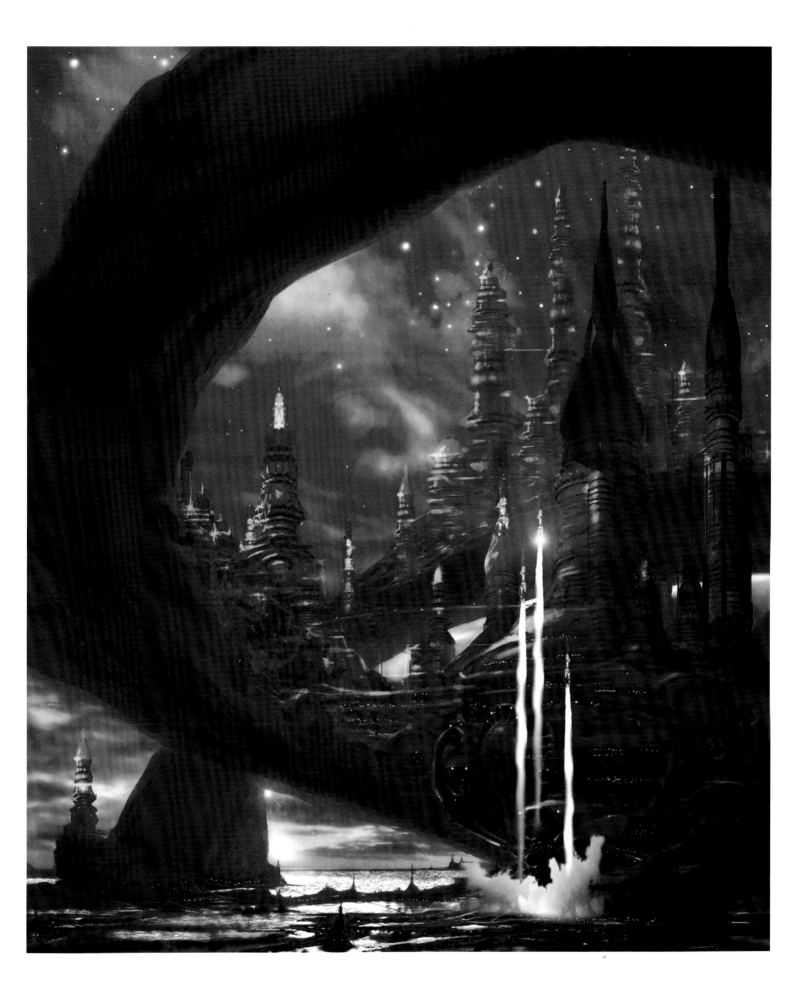

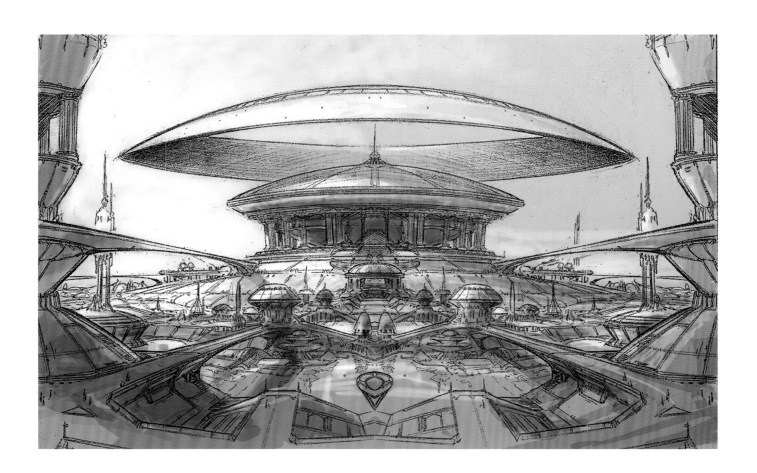

# THE RISEN EMPIRE

**book cover** | written by Scott Westerfeld

Book one of the series Succession.

A moon-size A.I. entity looms over the senate of the imperial city.

I wanted to explore a more graphic and somewhat impressionistic feel for this painting. I extensively used the unique brush palette I had created for architectural purposes. The use of these very geometrical shapes, along with scratching and chiseling layers, allowed me to obtain some very graphic and unique structures. The starting point for the mood was a reference of London bathed in a diffused light.

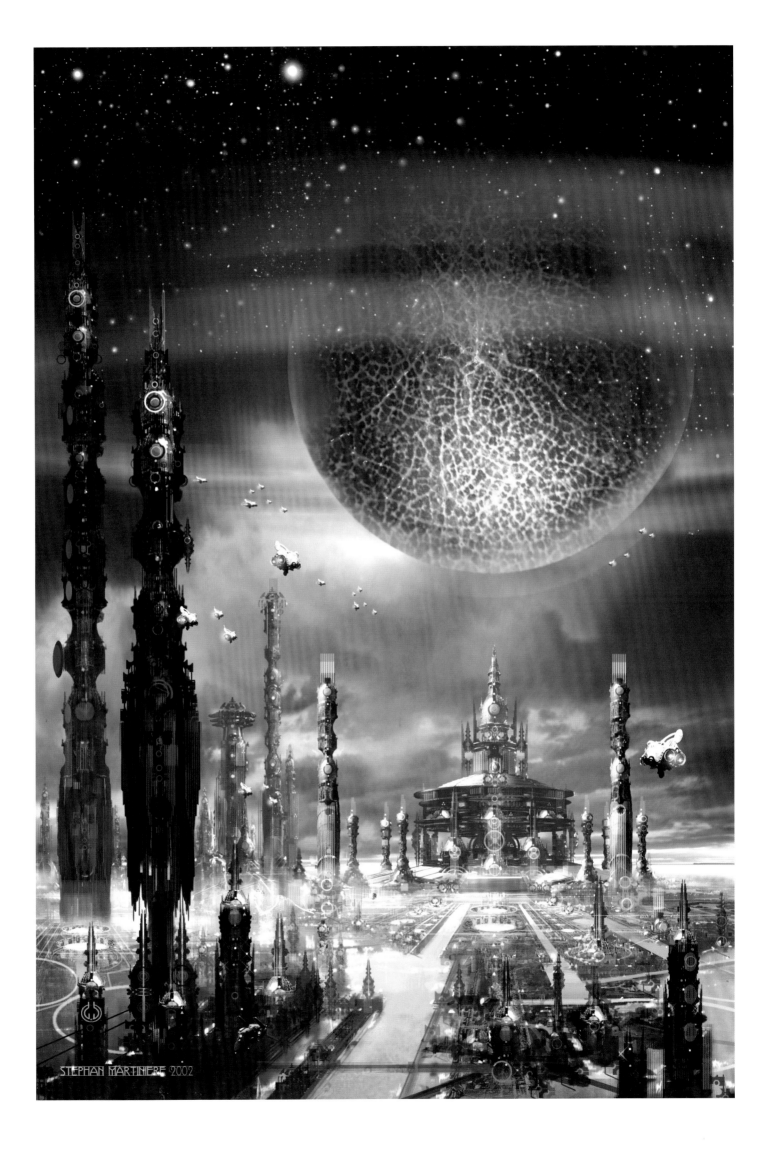

STEPHAN MARTINIERE 2002

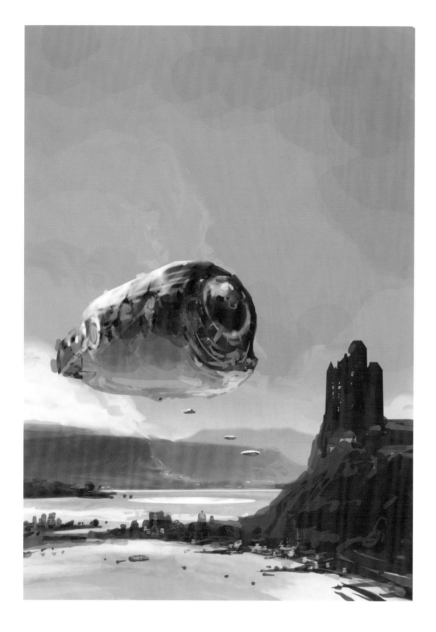

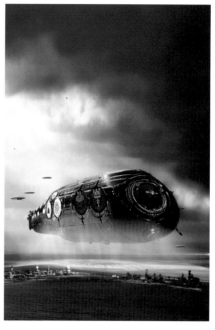

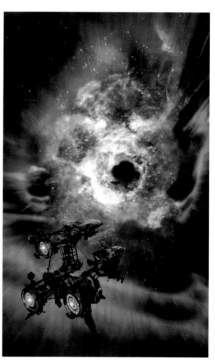

# COSMONAUT KEEP (The Engines of Light, Book 1)

**book cover** | written by Ken MacLeod

Aboard their behemoth star ship, the "Krakens," a squid-like species arrives on a distant planet where a small human colony lives.

The published cover is on upper right this page. The towers and the character in the foreground were added after publication. I didn't have the script when I was commissioned to do this painting. The study on the left was painted after the publication of the book, mainly for my own enjoyment. It might not carry that sense of foreboding that the original has but it is closer in the depiction of the city and the keep.

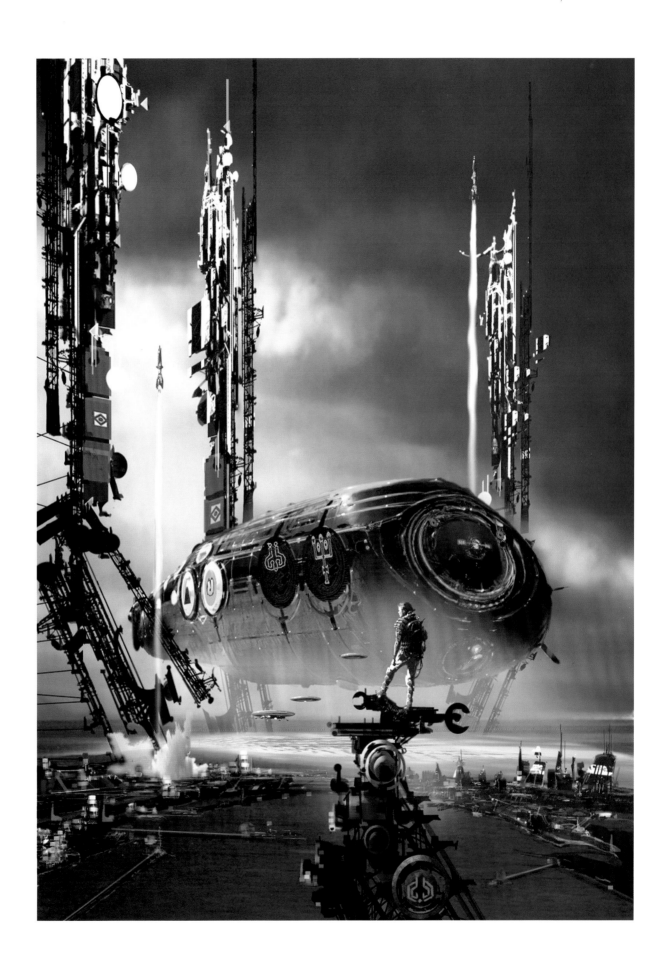

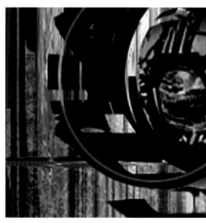

# NEWTON'S WAKE: A Space Opera

**book cover** | written by Ken MacLeod

On distant Euridice a military expedition from Earth discovers a strange artifact, an enigmatic and colossal cathedral-like structure made out of crystal.

A very Irish and Scottish feel came to mind as I read the manuscript. Some dolmens were also present in the landscape where the artifact is discovered. Based on that feeling, I decided to explore a mood using greens and warm grays. The main spaceship was described as some kind of enormous cylindrical shape made out of floating elements. Once that ship was placed next to the massive artifact, it suddenly became fragile, which created a nice contrast between the two kinds of technology. I kept the ships and characters dark to maintain their dangerous nature, the only light coming from their destruction.

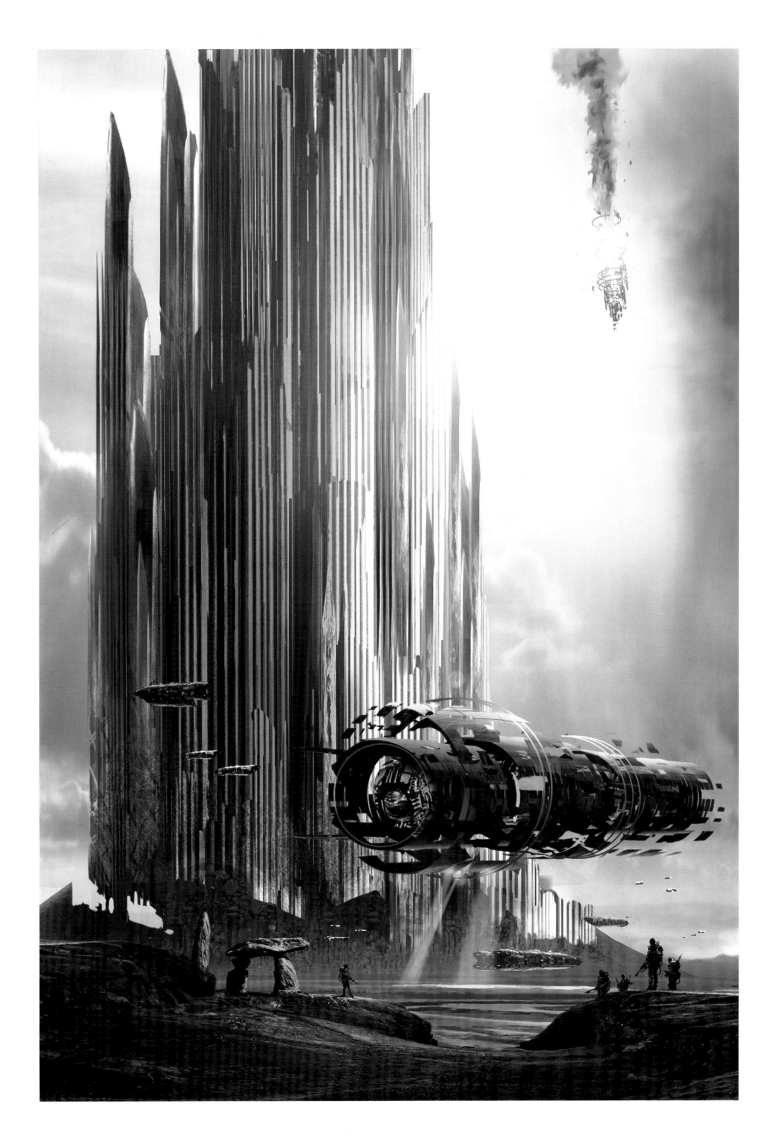

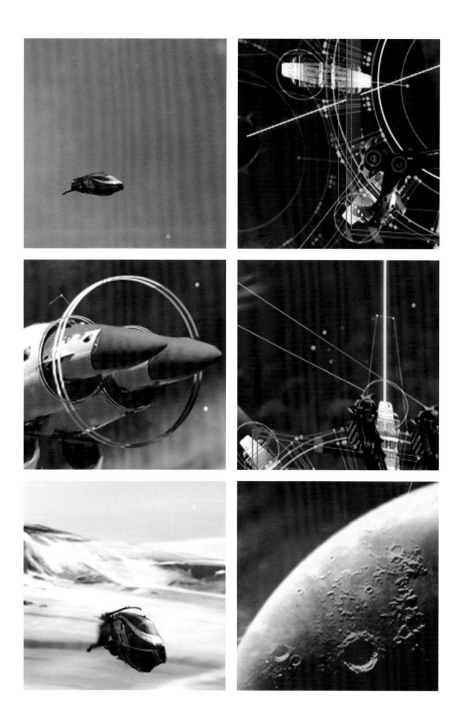

# PROBABILITY MOON

**book cover**  |  written by Nancy Kress

A spaceship is towing a dark artifact moon.

The F-16 fighter jet was my inspiration for the towing ship. I like its organic lines. The process to create the ship was similar to the one used for Red. I explored with multiple layers of elements, cutting, and painting over and under until a shape emerged. Some of the elements of The River of Stars were also used as part of the towing gear. The thin vertical line that extends up from the ship was intended to represent one of several kinds of gravitational measuring rays. I didn't add the other rays when I realized that the first one was acting like a string from which the ship and the moon were now suspended. I really liked that odd feeling.

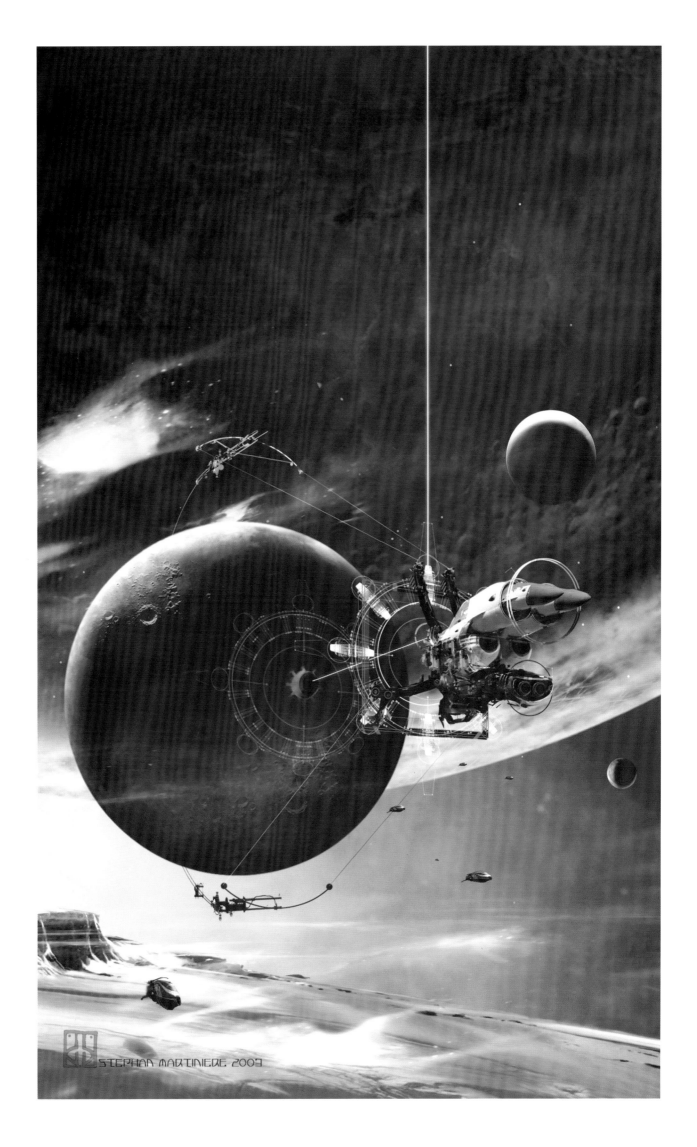

STEPHAN MARTINIERE 2003

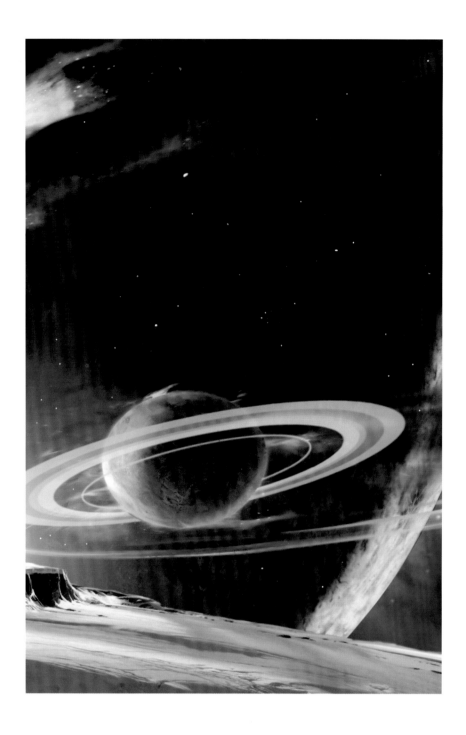

# HEAVY PLANET

**book cover** | written by Hal Clement

It is not always easy to give weight and motion to a planet in space. Since only void surrounds the object it often tends to float in the painting. The planet in the novel has an elliptical shape. This was a good beginning to carry a sense of motion. I added the trailing mist and floating particles to reinforce it. Adding the tilt to the planet and its rings conveyed weight, as did placing the open space below a hole that was created for the planet to fall into. Interestingly, the painting was published upside-down.

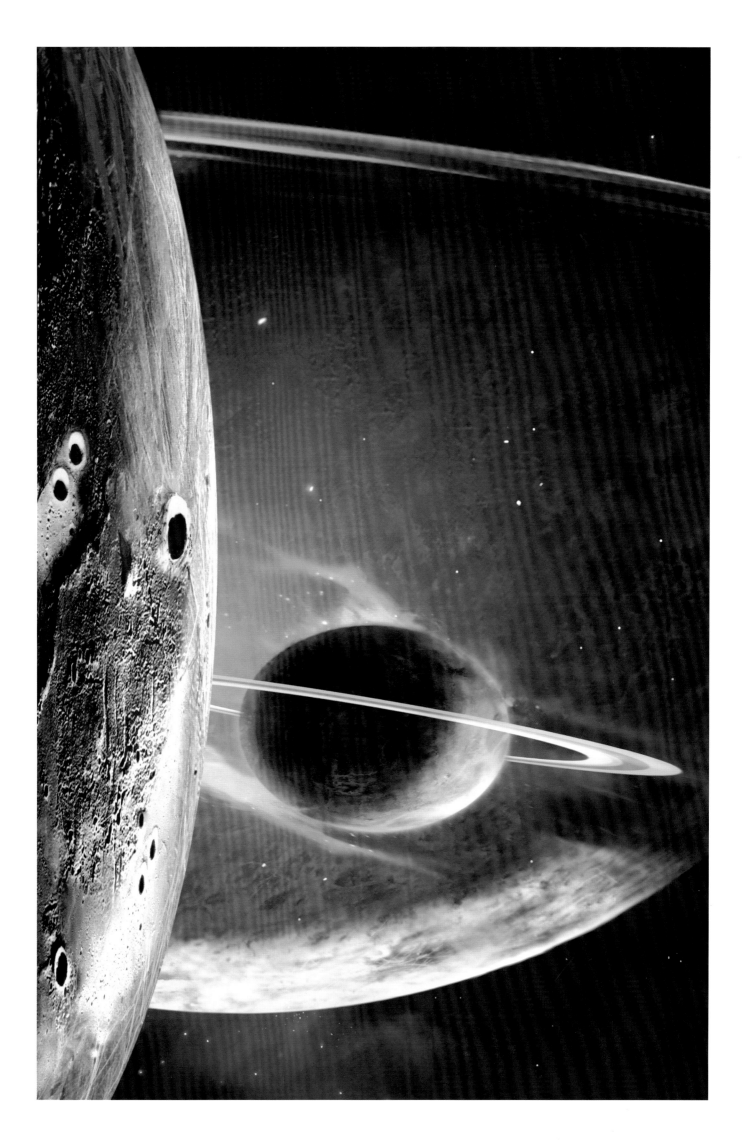

# THE WRECK OF THE RIVER OF STARS

**book cover** | written by Michael Flynn

Near Jupiter, a spaceship powered by miles-wide solar sails is in trouble.

The sail was created separately as a front view. Since everything is symmetrical I only had to create a quarter of it and mirror it. Then I used the distort tool to create the perspective in the painting. I copied it and reduced it to create the smaller sail in front of it. KPT Bryce was also useful in creating the asteroids.

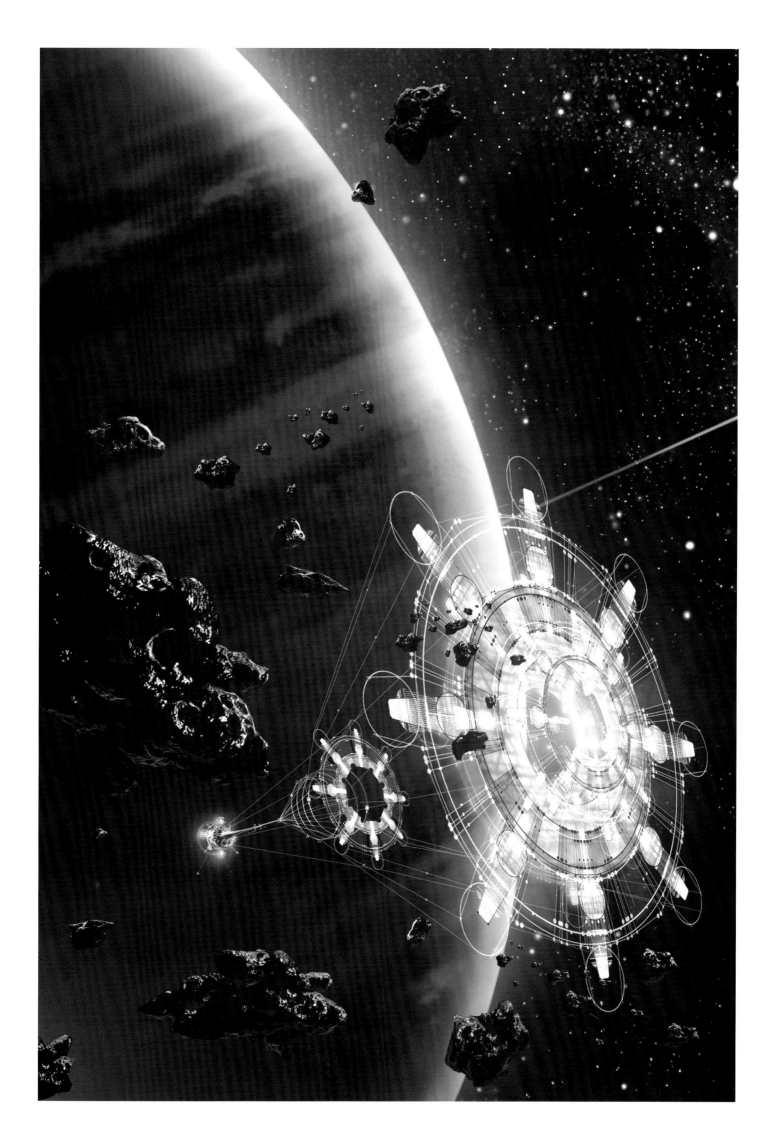

# STAR DRAGON

**book cover** | written by Mike Brotherton

A scientific expedition from Earth is sent to a binary star system and discovers energy-like creatures called "dragons."

The ship was described as a series of torus shapes using a push-pull propulsion system. A side view of the ship seemed to be the best angle to depict its functioning, but the composition using that view didn't satisfied me. A front view was definitely not going to work. A front three-quarter view seemed the most pleasing. It gave some depth to both the ship and the painting. The blue energy clouds in front of the ship are the dragons. I used several layers of various opacities to create the atmospheric strata of the star.

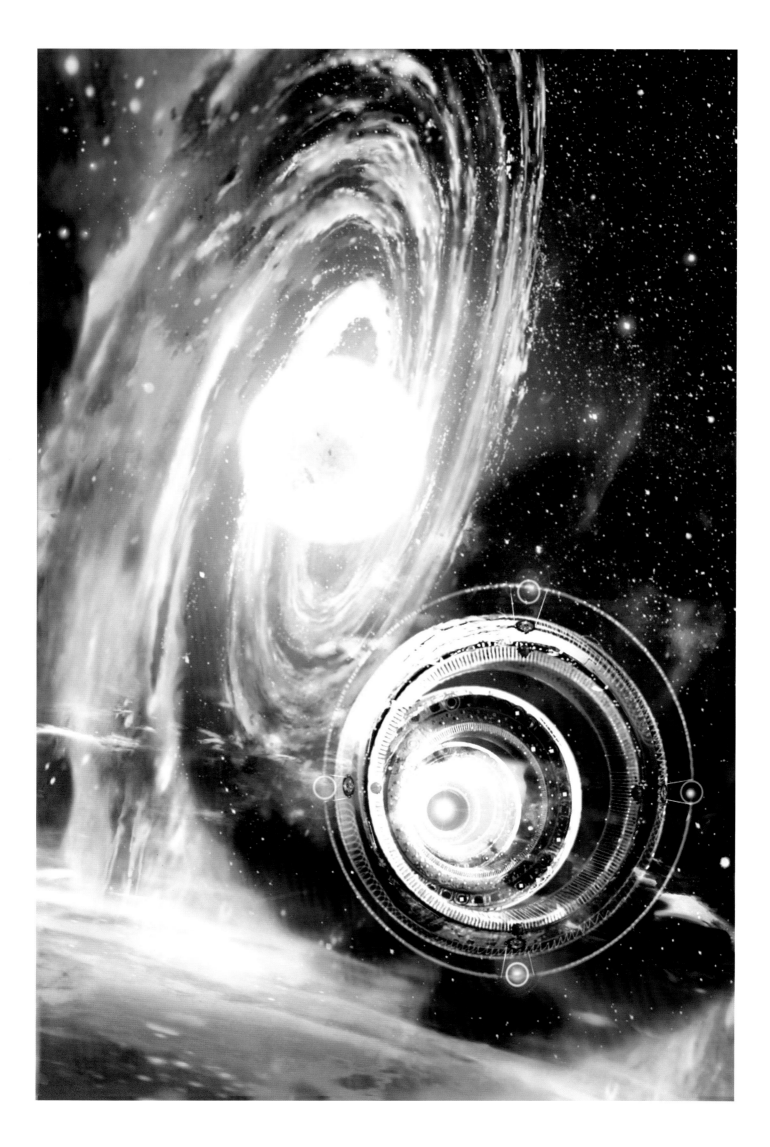

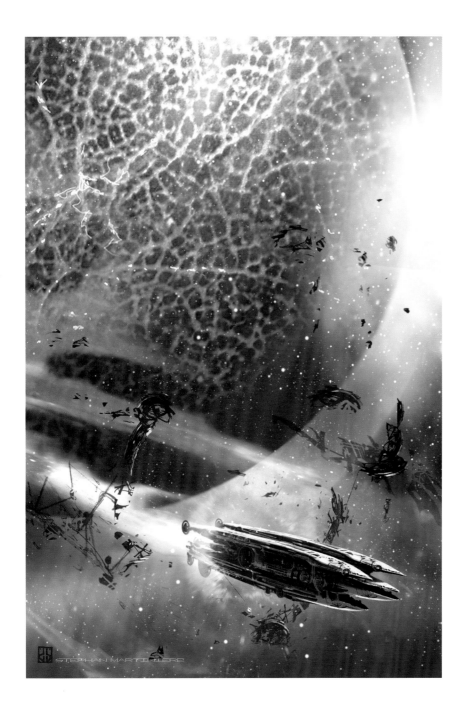

# THE KILLING OF WORLDS

compilation cover *(left image)*

**book cover** | written by Scott Westerfeld

Book two of the series Succession.

The spaceship, Lynx, is under attack by the enormous Rix.

The battle involved the use of micro-weapons, which were very hard to show next to the actual sizes of the spaceships. I decided to make them bigger to better illustrate the battle. Again, in this painting, I was very interested in the impressionistic feel. In retrospect I would have liked to add more detail to the Rix ship.

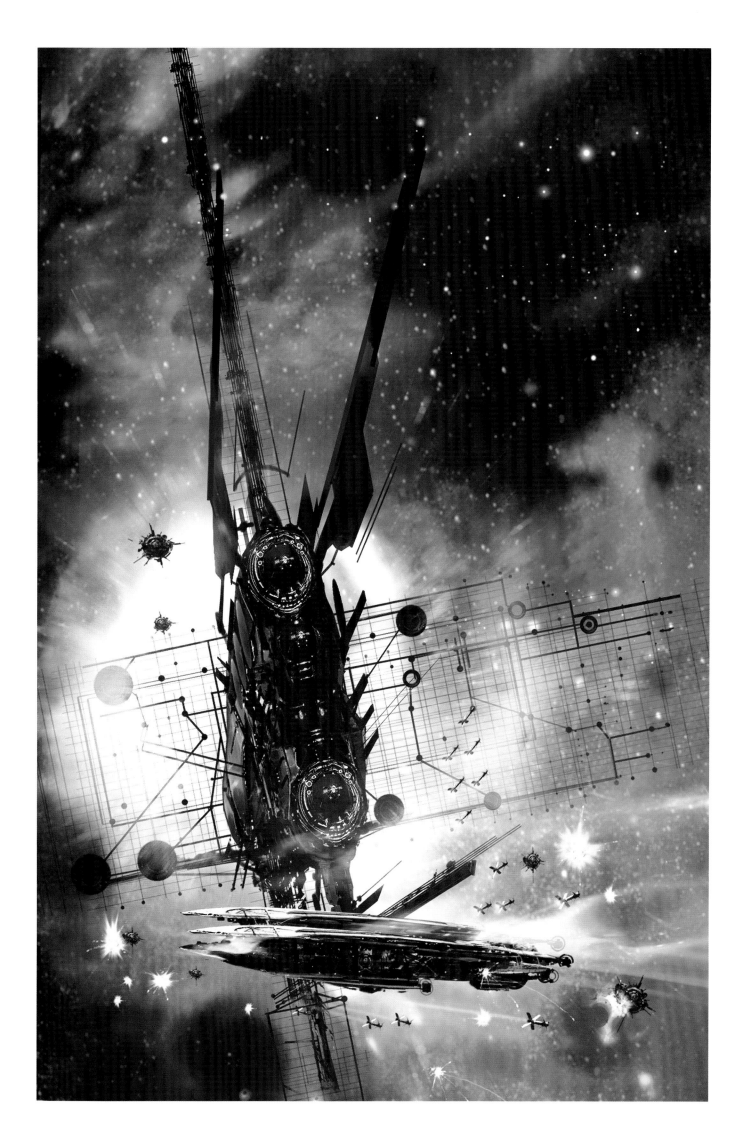

# LIGHT

**book cover** | written by John Harrison

A pursuit through space using what is described as "quantum events, non-commutative micro-geometries and short-lived exotic vacuum states."

Now how does one illustrate such a description? Since I never had the opportunity to see or experience such exotic vacuum states, I had to draw from my visual library and imagination. My choice was to use warped and flat grid planes and throw a variety of geometric lines to convey the idea of a mathematical diagram. I hope I conveyed the idea but at least it created an interesting painting. The big alien ship started from a rough black shape. I knew I wanted a spherical body with large vertical wing, something very iconic. I let the process of juxtaposition, using thin layers and scratching, dictate the volumes and details of the ship.

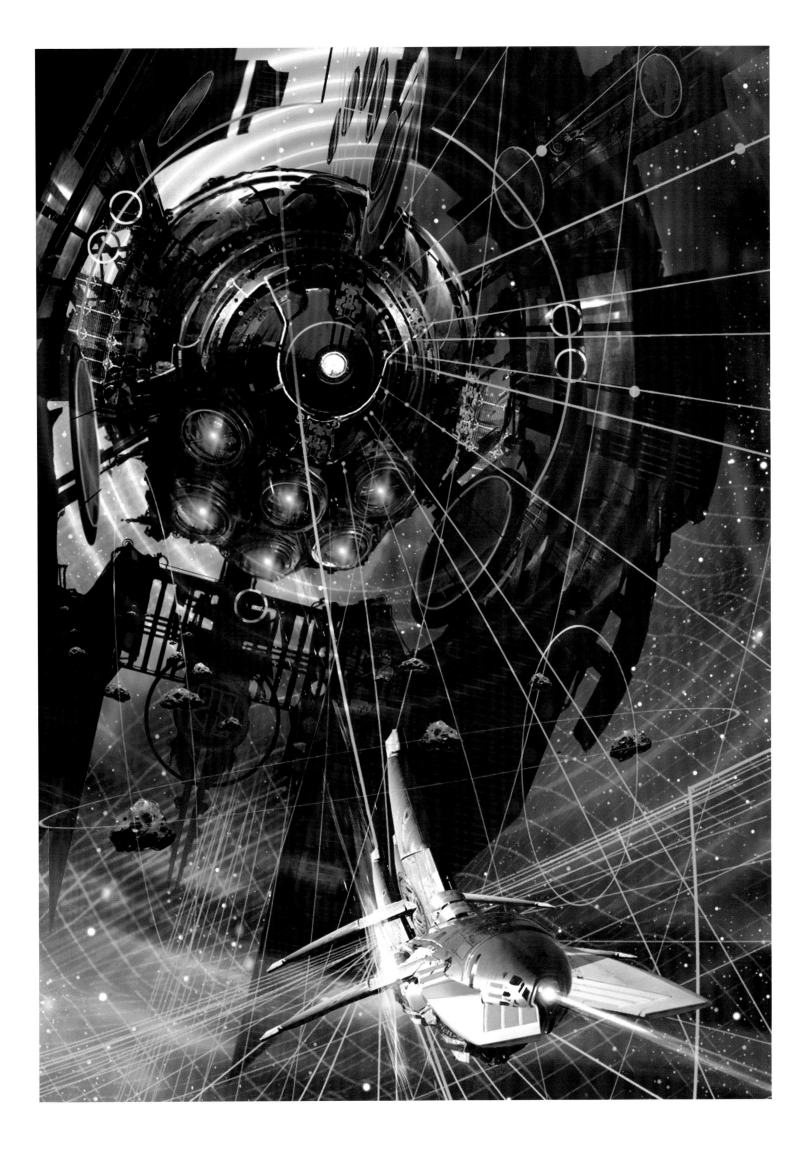

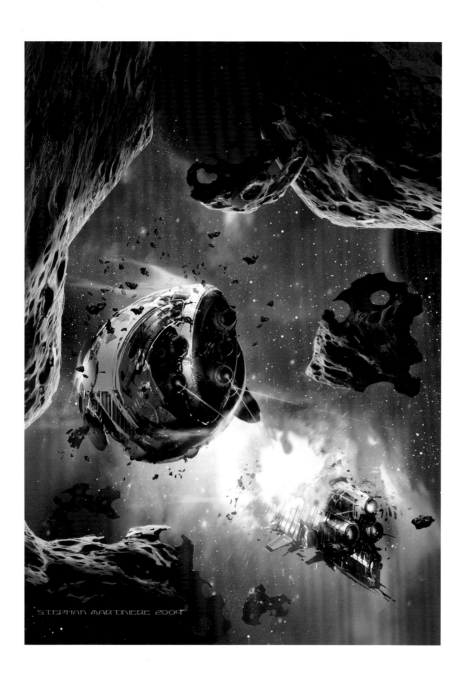

# THE SILENT WAR

compilation cover *(left image)*

**book cover** | written by Ben Bova

Deep in the asteroid belt a pirate spaceship preys on cargo vessels.

Unlike my previous paintings involving asteroids and the use of KPT Bryce, I wanted to explore something different and give the space rocks a more painterly feel. The big one was created using a lot of the thin layering and scratching technique.

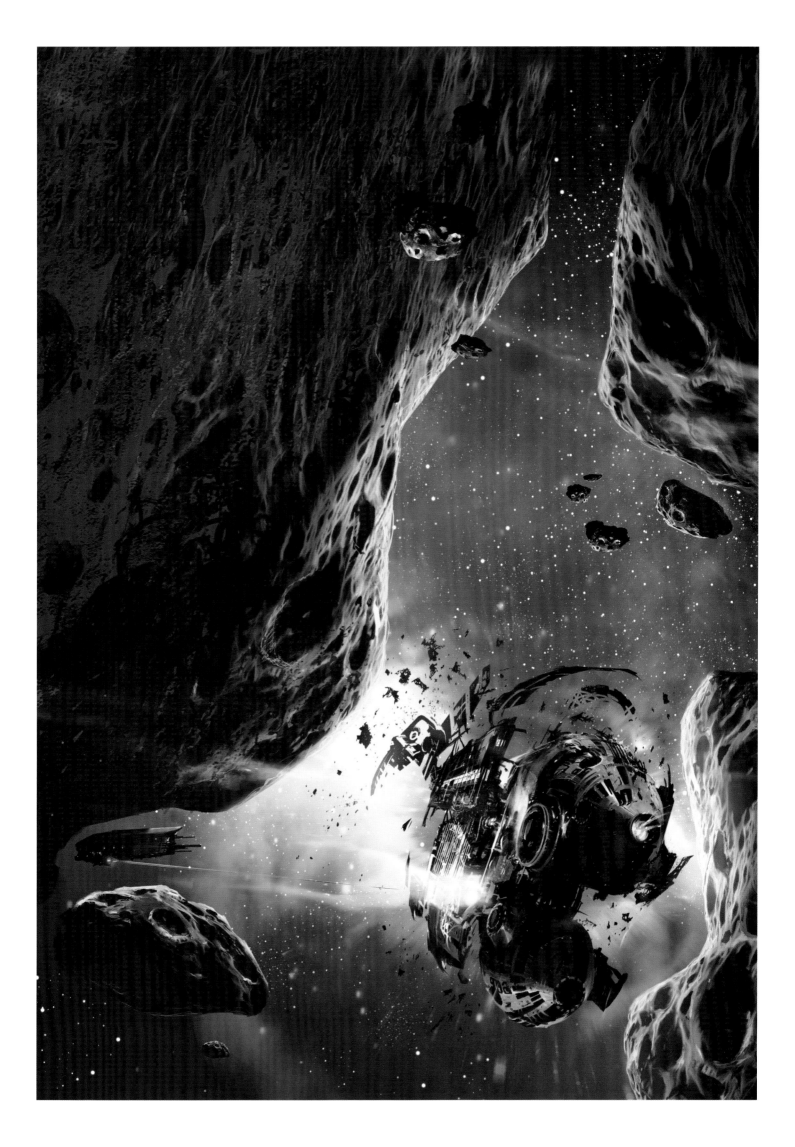

# MANTA'S GIFT

**book cover** | written by Timothy Zahn

Between the many layers of Jupiter's atmosphere a sentient race of giant manta-like crea-tures is discovered. This was the first painting where I made an extensive use of the paint and smudge tools. I wanted to give the clouds a very painterly feel.

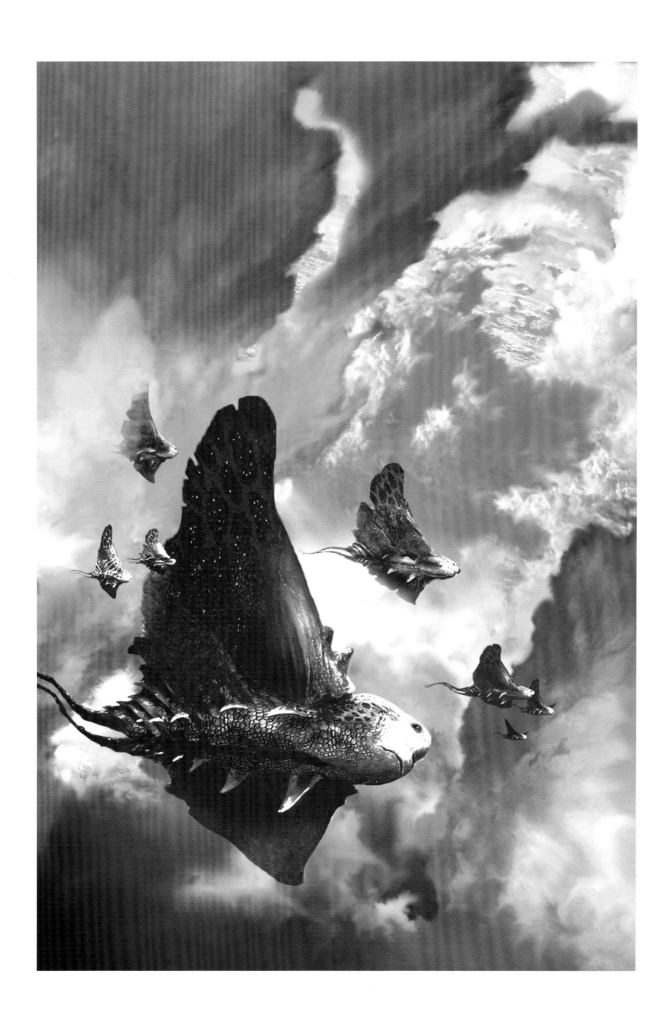

# POLYHEDRON

magazine cover

Join the mecha corps!

The idea was to create a Soviet-type propaganda poster. Giant mecha robots and a female pilot holding her helmet look toward a bright future. I enrolled my friend, Jessica, as the model and she turned out to be perfect for the role. It was important to me to give the illustration a painterly look. I found the smudge tool very useful for mixing and blending color and references. I like its organic feel. However because it's not quite the same as mixing with a real brush and tends to push colors, it requires a certain degree of control and the addition of more paint.

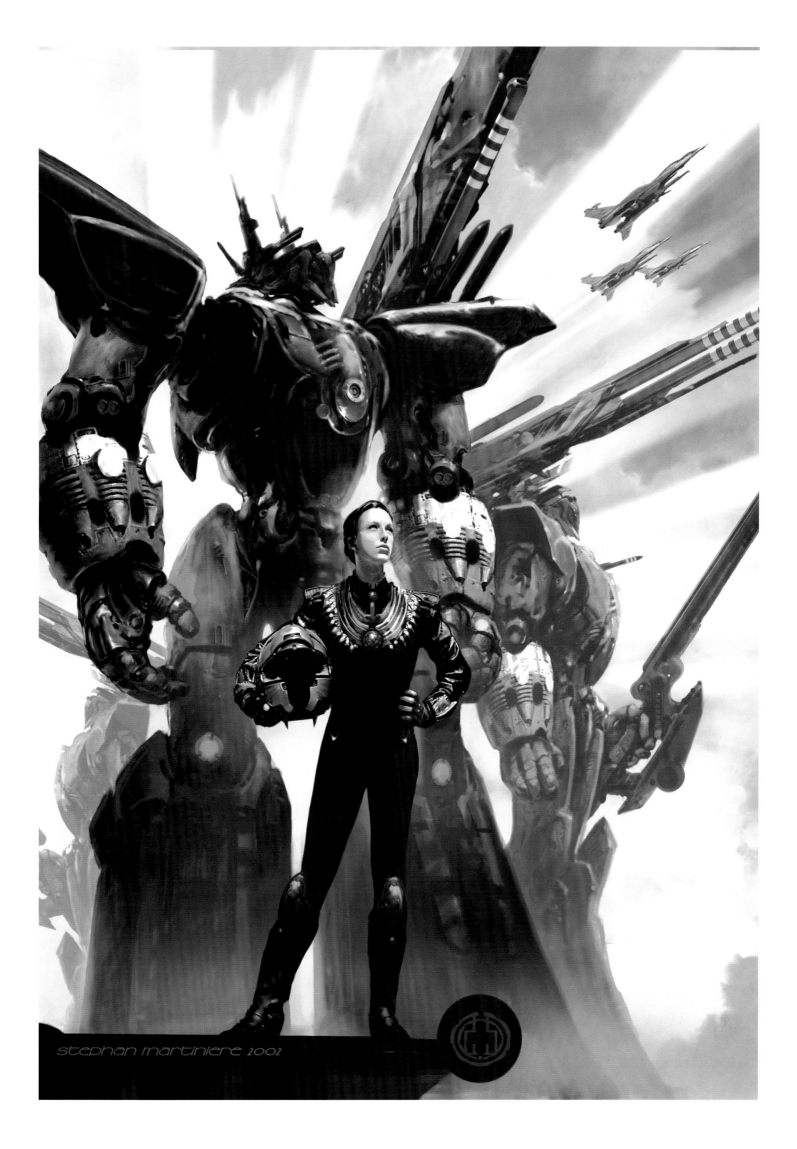

stephan martiniere 2002

# HOSTILE TAKEOVER

**book cover** | written by Sandra Shwartz

The request from the art director was simple and straightforward; "babe in space with a big gun." I had done the Polyhedron Magazine cover a year before, depicting a pilot babe with mecha robots, so I wanted to do something different. I chose orange as an overall color simply because I hadn't done a lot of paintings in that color palette. It also happened that Jupiter was the location of the story. It was a perfect choice. The painting of the character uses a lot of a technique I refer to as "scratching," juxtaposing different colored layers and using the eraser to scratch/uncover the layers underneath. I find the technique very direct and gestural.

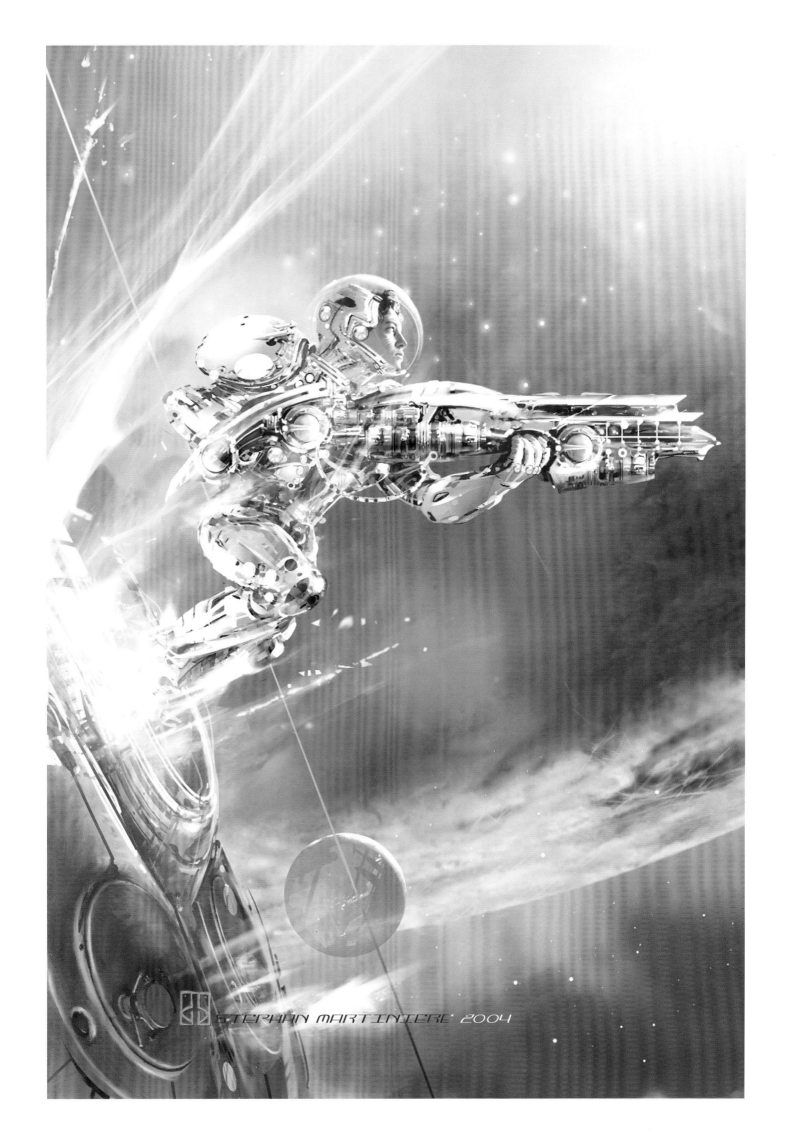

STEPHAN MARTINIERE 2004

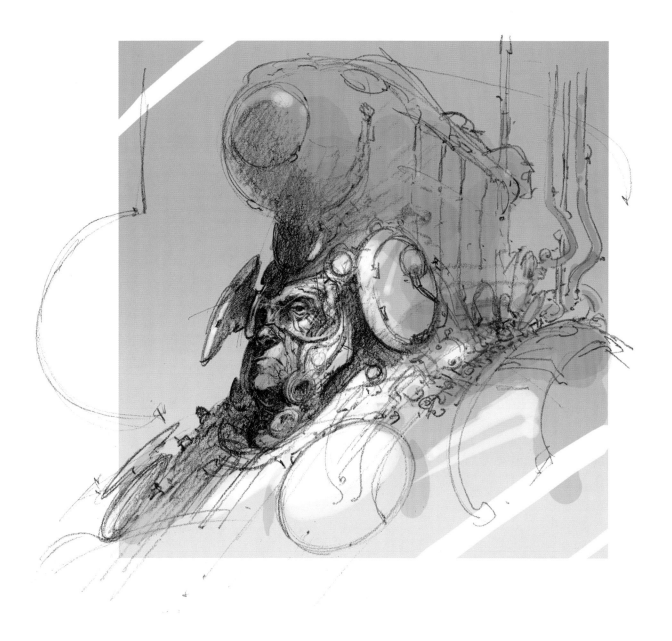

# RED

**personal project**

Old tractors inspired me to do this painting. I had no particular idea of the outcome. It became a creative exercise as I was gathering elements on multiple layers and started painting and scratching over them. Shapes started to emerge and eventually the idea of a heavy spacesuit established itself.

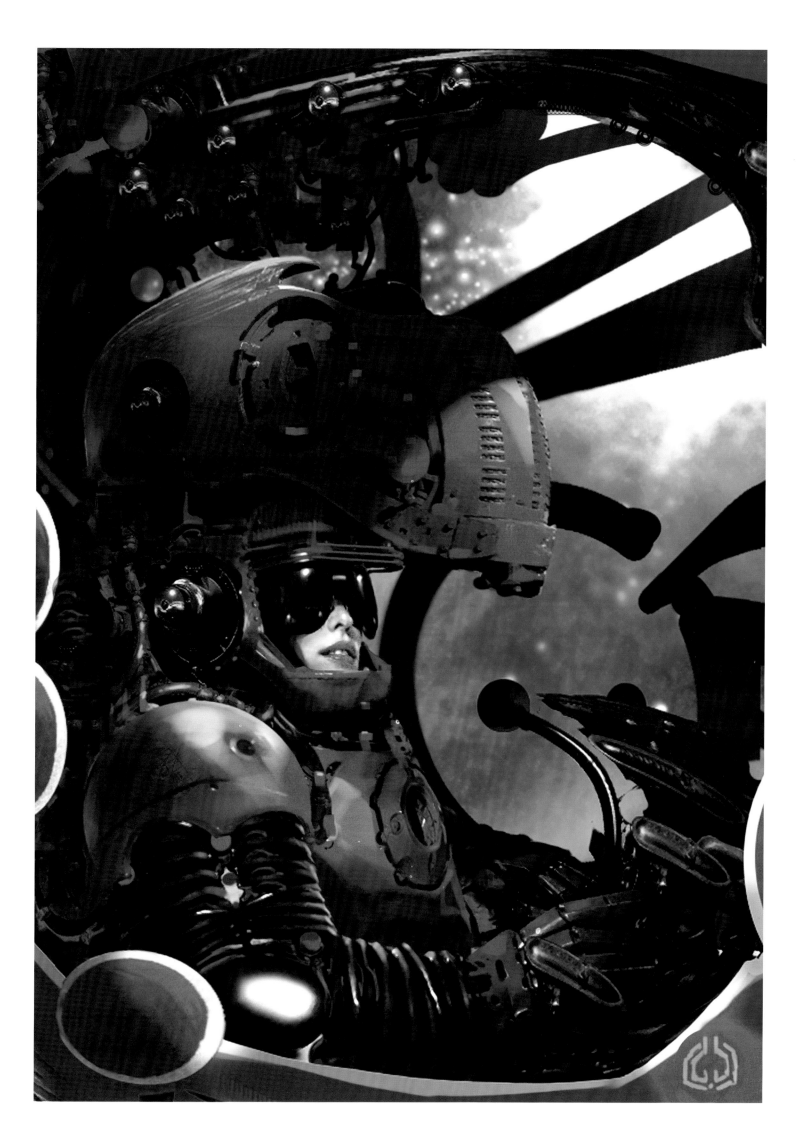

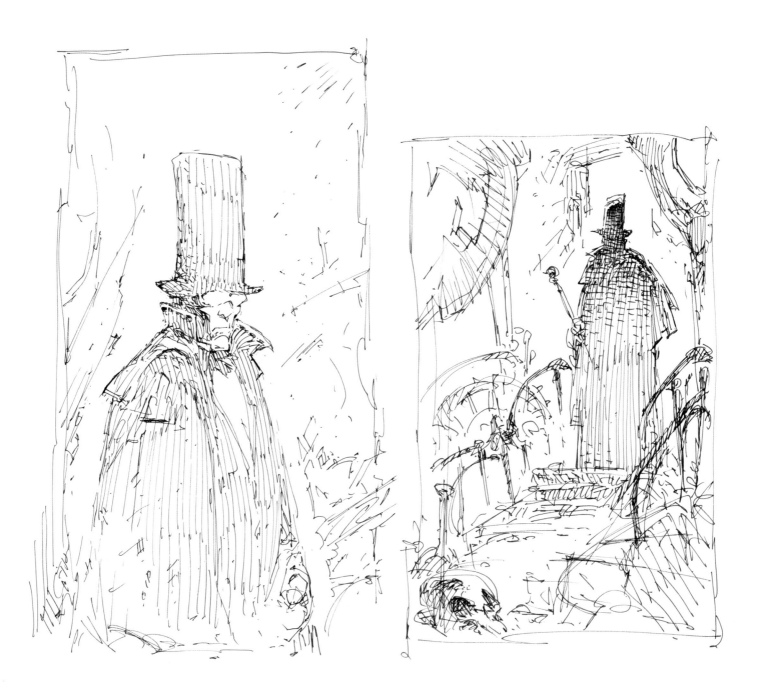

# THE VICTORIAN

pinup insert

My own interpretation of the superhero.

I wanted to explore a fast and aggressive gesture technique using the scratching method to define a unique style. I stacked layers of paint or references on top of each other, and started to boldly remove pieces of it with various hard erasing brushes. The result was very sharp looking. I could see the beginning of something very unique and personal.

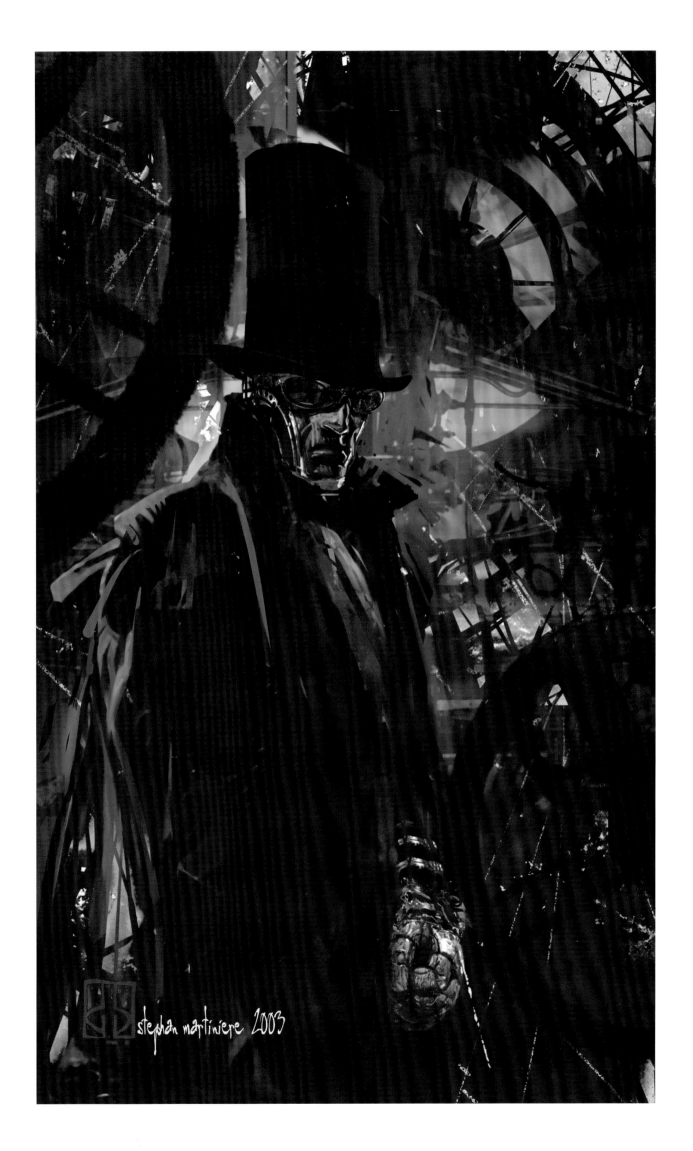

stephan martiniere 2003

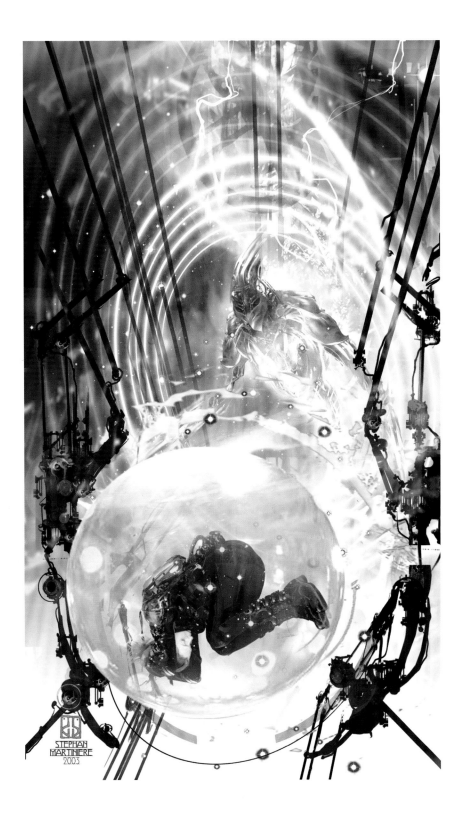

## PARA 1

*Para 3 (left)*

*comic book cover for the series "Para."*

This series was an X-Files-type mystery with a poltergeist flavor inside an abandoned particle accelerator. I wanted to continue exploring the fast and aggressive gesture technique I used for the Victorian painting. I was the most successful with this technique on the upper left corner.

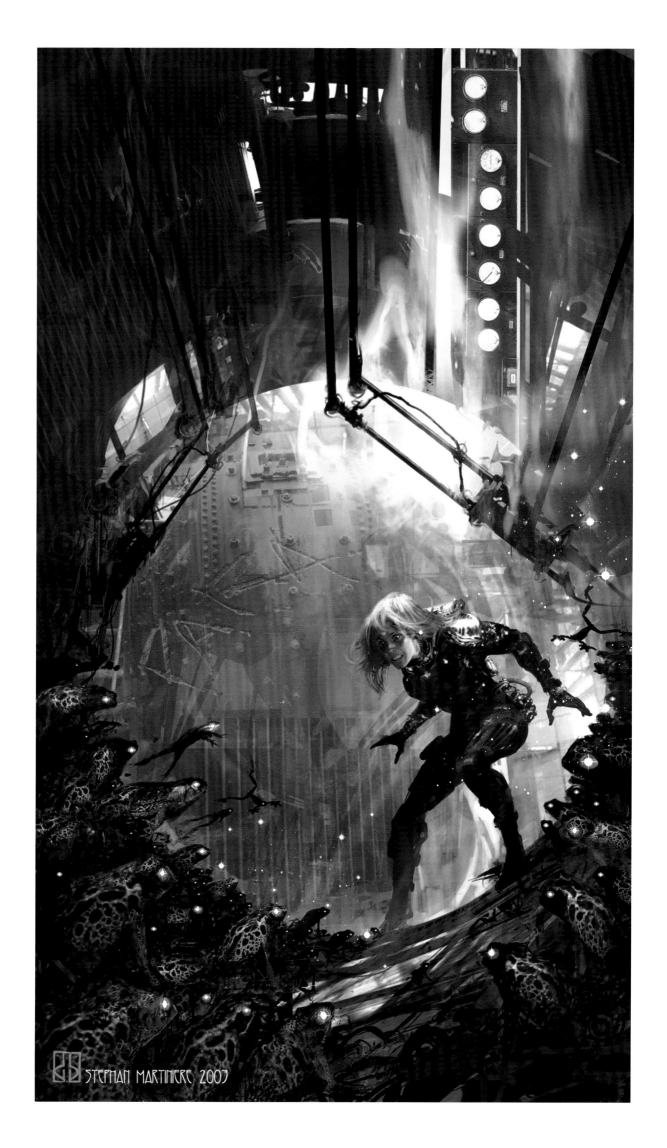

STEPHAN MARTINIERE 2003

# PARA 2

comic book cover for the series *"Para."*

Sara, the main character, is in a trance state, kneeling on top of a piece of machinery.

The story deals with metaphysics. Sara is a witness and will be given a glimpse of a transcendental universe. The composition uses curved lines spiraling to the center where Sara kneels, immobile, like a seed at the center of an egg. The alien energy around her feeds her, and prepares her for a new awareness. That second cover was a further exploration from Para 1. Aside from Sara's face, which remains soft and serene, the rest of the painting is rendered with very bold and aggressive strokes. It reinforces the chaotic nature of the story. By reusing elements of Para 1 and pushing the scratching gesture, the painting became very graphic and somehow impressionistic. I was very pleased with the result.

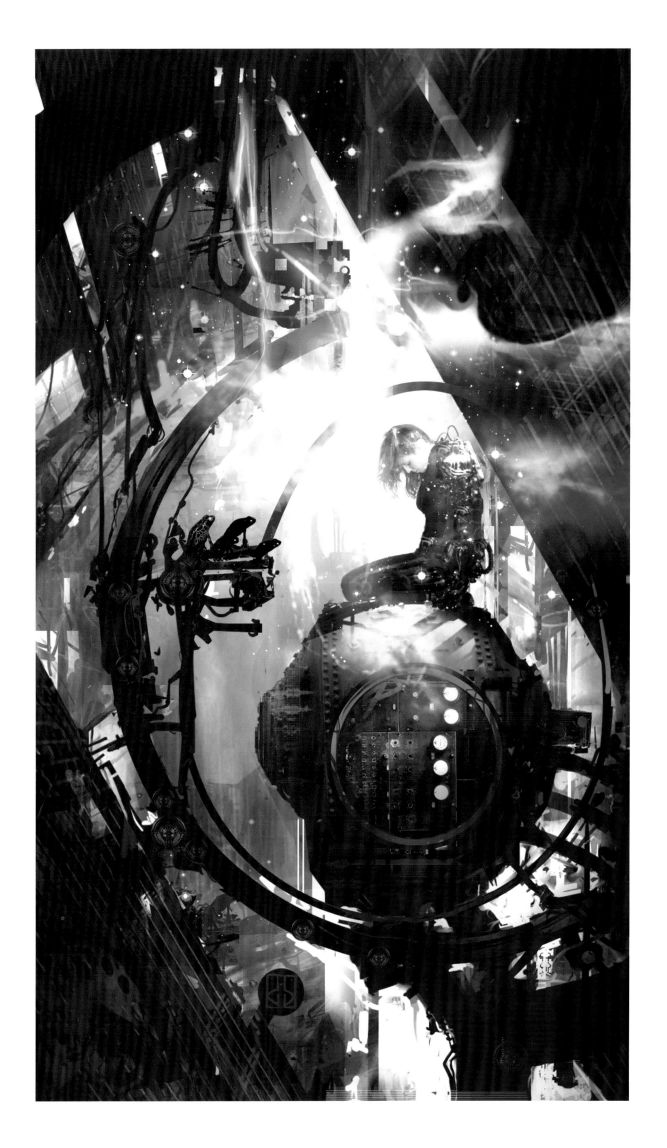

# PARA 4

comic book cover for the series "Para."

Sara confronts the robot.

This painting goes a step further in using the scratching technique. By reusing even more scratched layers from the previous paintings, and adding more scratching on top of them, the elements brake apart. The painting starts to explode. The robot and its surroundings acquire a very interesting dynamism.

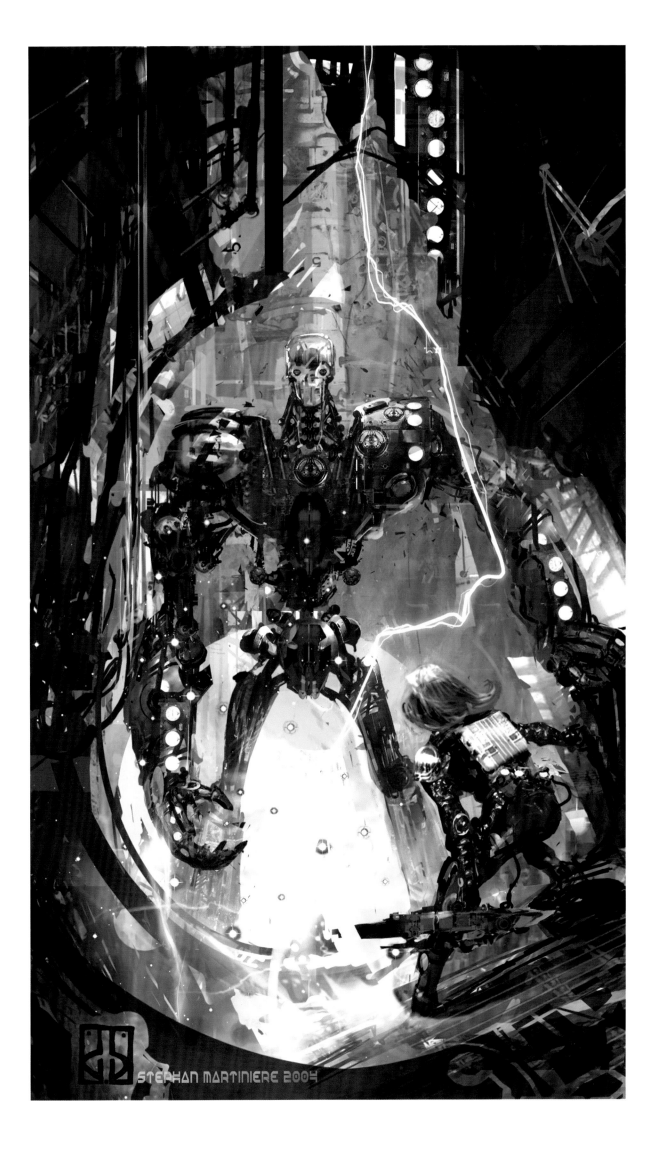

## PARA 5

comic book cover for the series "Para".

Sara in a heroic pose.

I was short on ideas for that cover, so I decided to keep it simple and concentrate on a portrait of Sara. I always admired the technique of J.C. Leyendecker, and thought it might work well with the results that the scratching and layering were showing. To achieve a good result on Sara's face, the scratches had to be more controlled. I was very satisfied with the end result.

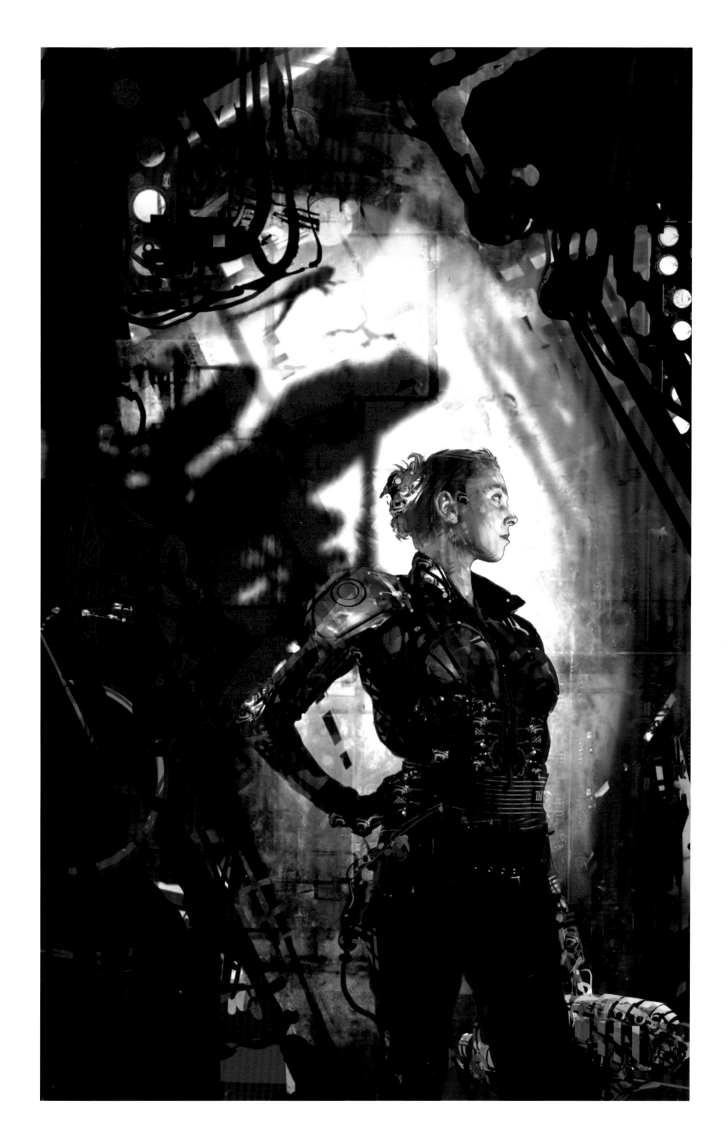

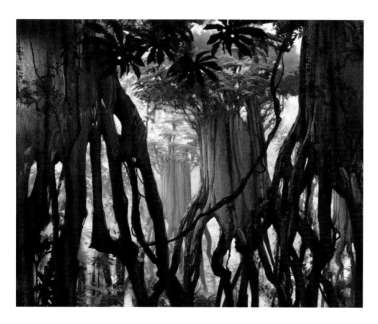

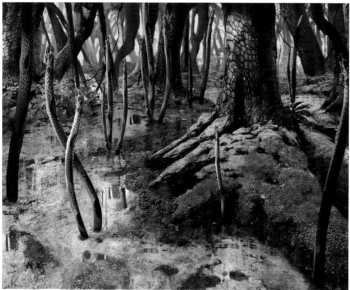

# NEGILAHN JUNGLE

Jungle Down *(above)*, Jungle Up *(top left )*, Jungle Straight *(opposite page)*

concept painting for the computer game *URU, Ages Beyond Myst*

Myst and its sequels, including URU, are a fabulous universe where a player is transported to strange and mysterious worlds, called "ages," to solve complex puzzles. The graphic quality of these games has earned Cyan an unparalleled reputation. As the visual design director for Cyan, I had almost complete freedom to explore fantastic new ideas, and as an artist it was equally rewarding. I approached every new "age" with preliminary sketches to nail down the ideas. I then moved on to create several detailed paintings to set the tone for the entire age, and give the maximum information to the 3D artists. It was important for me to stay very close to what the end result would be in 3D. Since the texturing for the game was created using photo sources, I used the photo library as much as possible, often adding my own to the database. These paintings are less about style, and more about texture and realism, and therefore they have a more photo feel.  The technique approach is similar to the one I used for the book cover paintings. I juxtapose different layers at various opacities to establish the mood and the foundation. Then I continue the process by painting and blending but the last covering layers will be more about the texture to be used for the game.

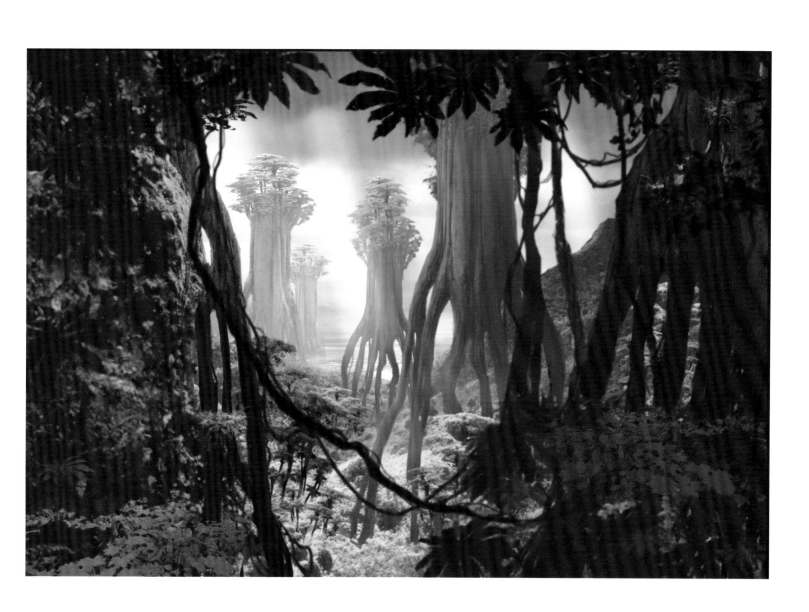

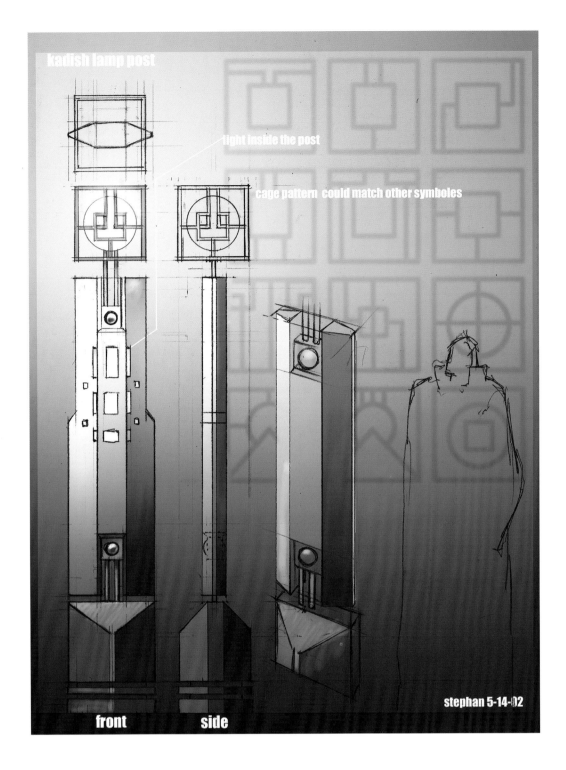

kadish lamp post

light inside the post

cage pattern could match other symboles

front        side

stephan 5-14-02

# KADISH - the path

lamp post *(left)*

concept painting for the computer game *URU, Ages Beyond Myst.*

This is where the player first appears in the "age." Before my involvement on URU, the game was predominantly orange and brown in color. I wanted to stray from it and come up with something different. For Kadish I decided to use an overall bluish tone. The "age" introduces you to a ruined mansion overtaken by a giant forest. It also deals with death. To convey that feeling I used a texture on the trees that could be reminiscent of fossilized stone.

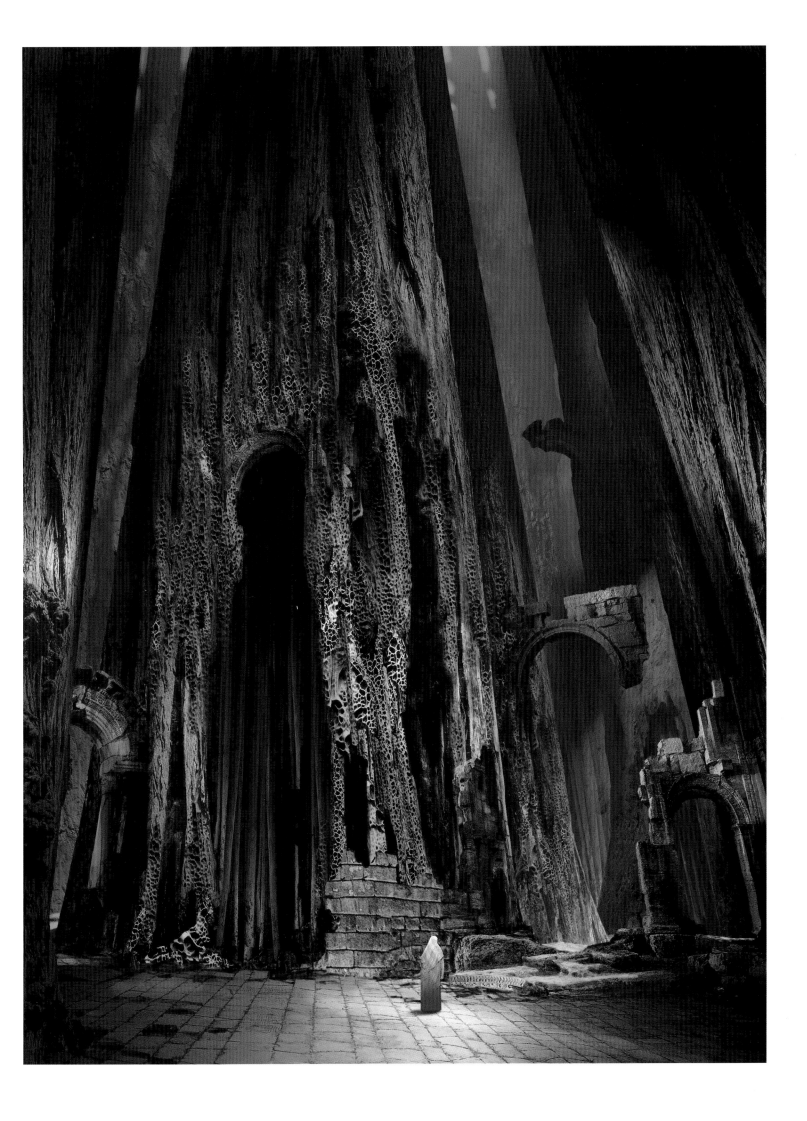

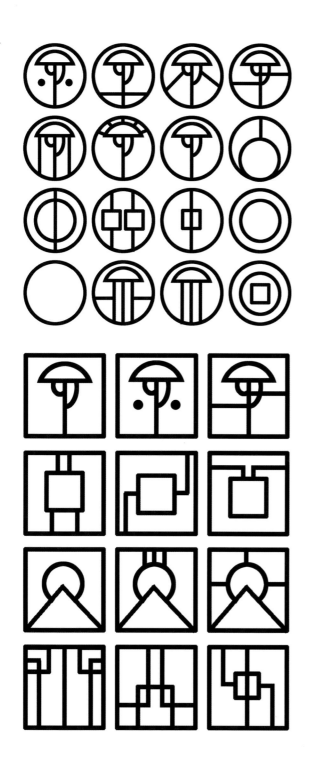

# KADISH - the vista

logos *(left)*

concept painting for the computer game *URU, Ages Beyond Myst.*

As the player follows the intricate forest path, the view suddenly opens up revealing Kadish's scale and beauty. This is the only moment during the exploration of Kadish where the player can experience the scale of the entire "age" and get a sense of the trees' gigantic size and the stillness beyond the forest's edge.

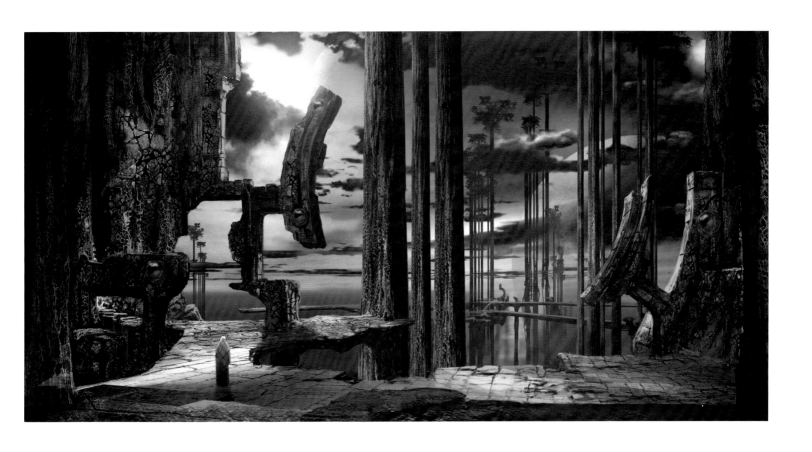

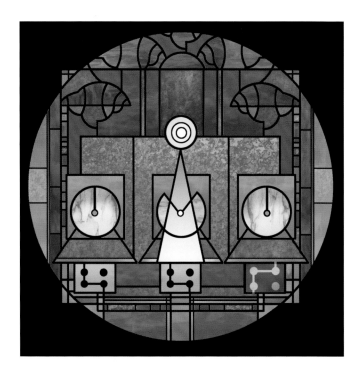

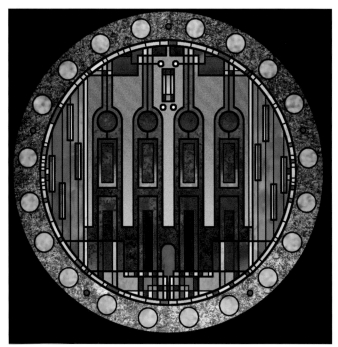

# KADISH - the pyramid

gallery paintings *(left)*

concept painting for the computer game *URU, Ages Beyond Myst*

Kadish is a mysterious place where symbols are omnipresent, often hidden as details, but sometimes overpowering in size. I wanted the pyramid to be symbolic but also very iconic, built with obvious geometrical elements. It was important that the player be able to easily remember its design, and then to use that memory to solve puzzles. The pervasive cracks in the stones came from photo references taken during a trip to Santa Fe.

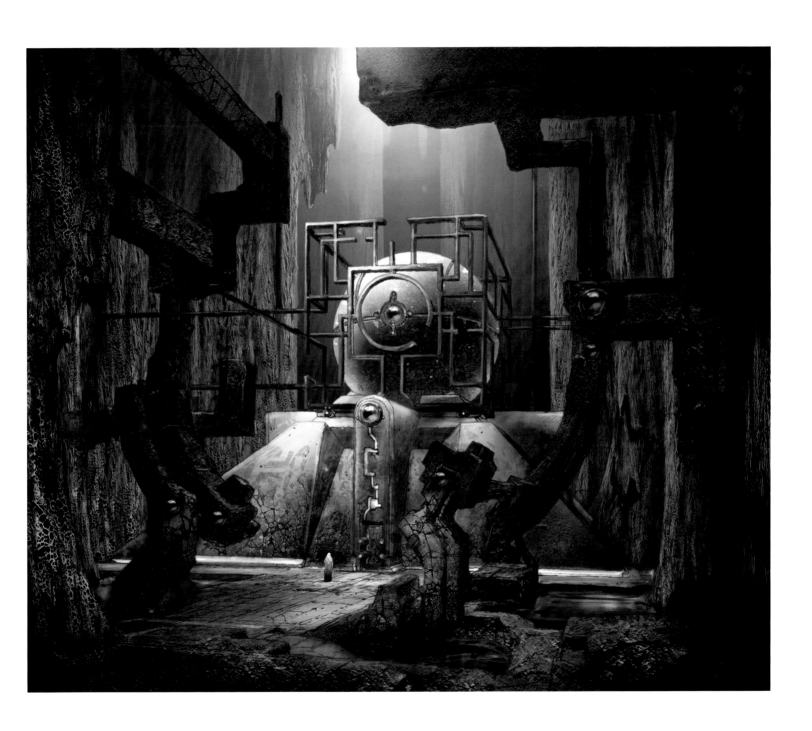

# KADISH - the safe

concept painting for the computer game *URU, Ages Beyond Myst*

Once again the player is confronted with a structure both symbolic and iconic. The idea was to convey a feeling of entrapment but also of revelation using a spider web design. Protective walls now in ruins have been pulled apart by the tree roots to reveal the dark and mysterious monolithic safe.

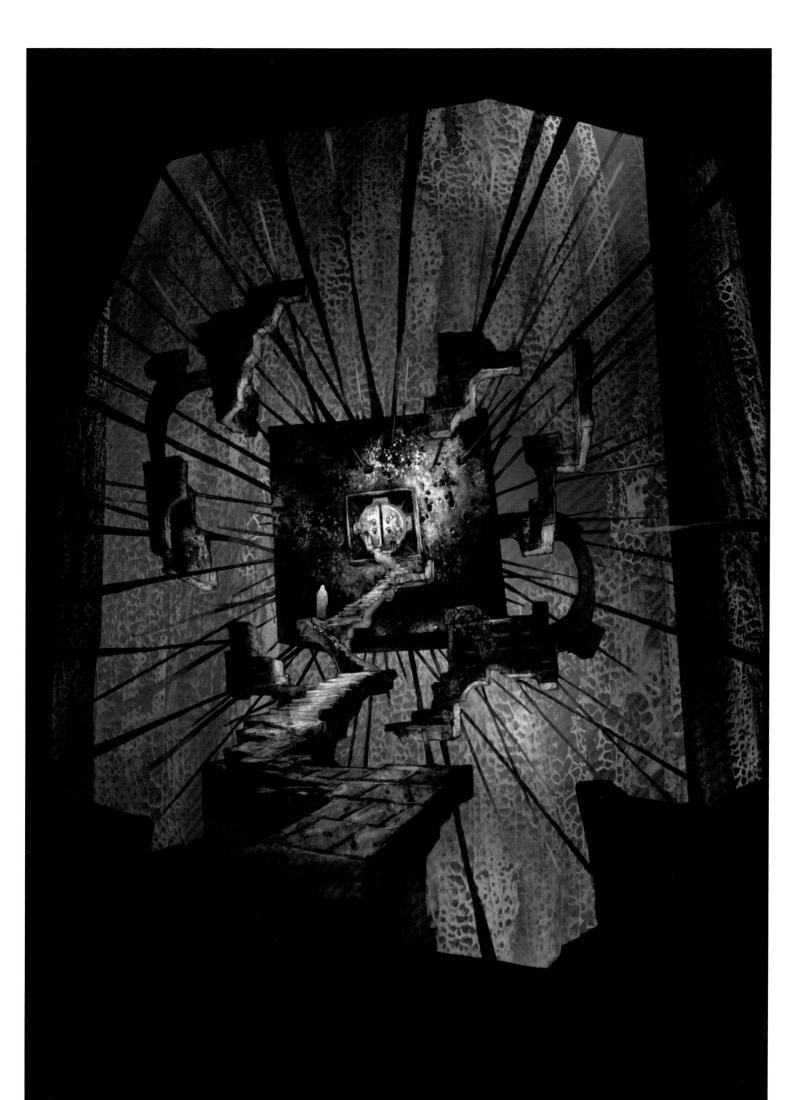

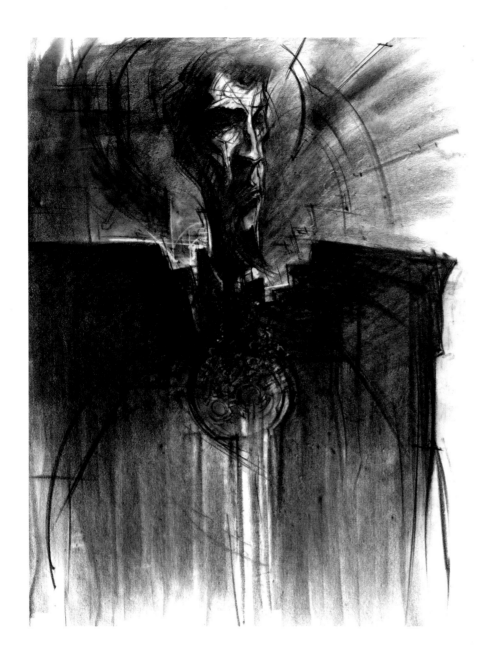

## KADISH - Ahlsendar, the Great King

concept drawing for the computer game *URU, Ages Beyond Myst* | *charcoal, 21x27 inches*

In the game, the way the "D'ni" people depict themselves artistically is often, if not always, disproportioned. They like to emphasize their bodies and shoulders to downplay their head size. When this assignment came, I thought it would be a great opportunity to get my feet wet again doing something I hadn't done for years: drawing a large portrait in charcoal. At first I felt a little unsure, but to my surprise, I discovered that it's like riding a bicycle—you never really forget. I was a little rusty in my first attempt but the final piece came quickly and assuredly. The color was done digitally by applying a thin yellow wash enhanced with a few details.

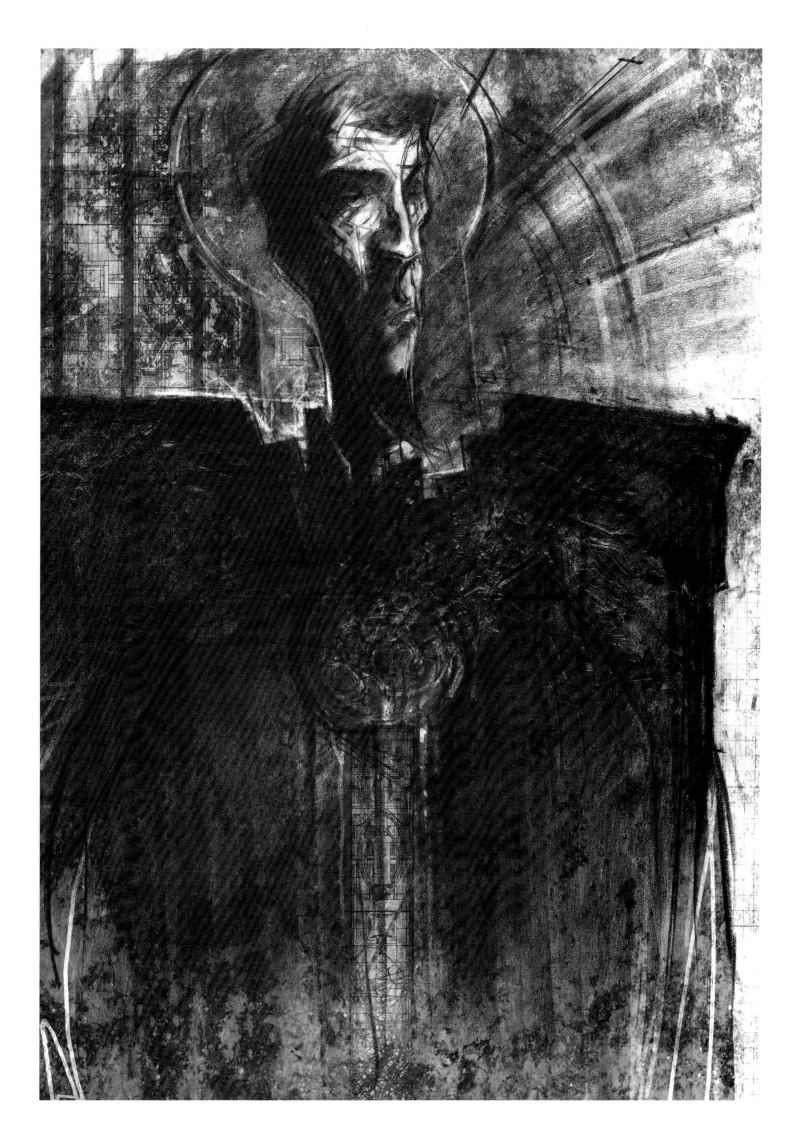

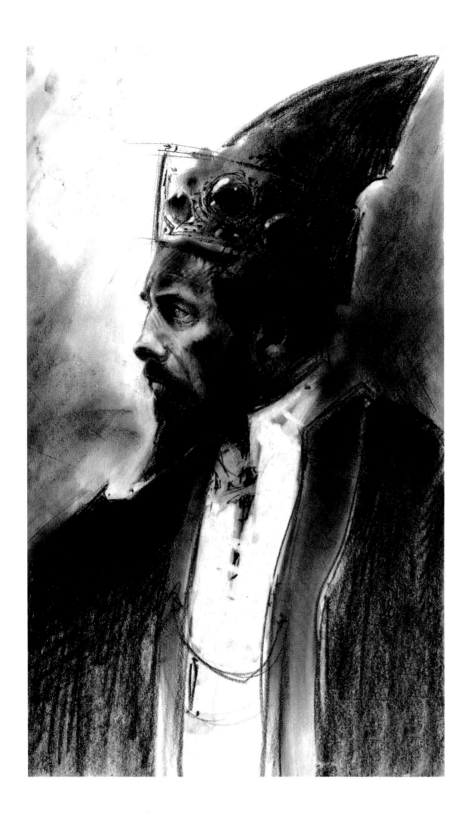

# KING KERATH

*concept drawing for the computer game URU, Ages Beyond Myst | charcoal 13x21 inches*

After The Great King I was asked to do a sketch for another "D'ni" king. After my successful
first drawing in charcoal, I decided to continue the royal series using the same medium. I did
a less stylized version, something more classic. The color was applied the same way as The
Great King.

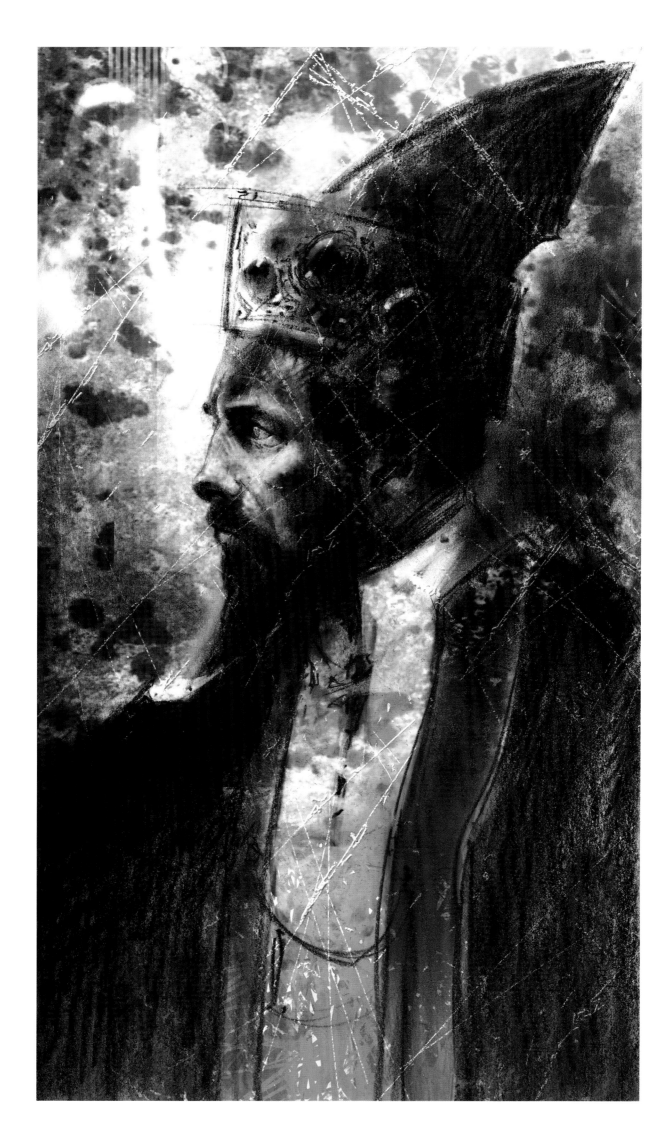

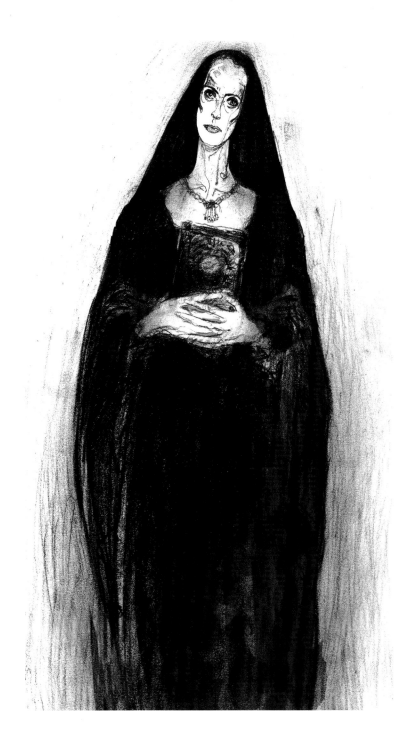

# QUEEN LALEN

*concept drawing for the computer game* URU, Ages Beyond Myst | *pencil and charcoal 11x17 inches*

It was a time of great suffering. The plague was upon the D'ni people and their King Hemelin was dying. While on his deathbed, King Hemelin fell in love with a woman named Lalen. It was Lalen who discovered the clues that led to the discovery of the lost books of Berenni and the cure to the plague.

The sketches of Egon Schiele inspired me when I did this drawing. There is great sadness and anguish that transpire from his portraits and I tried to capture that feeling as I was drawing Queen Lalen. I added more elements during the color stage, a lot of hinting symbols related to death, and the D'ni burial practices. If you look closely, you can see a skull pattern hidden in the texture.

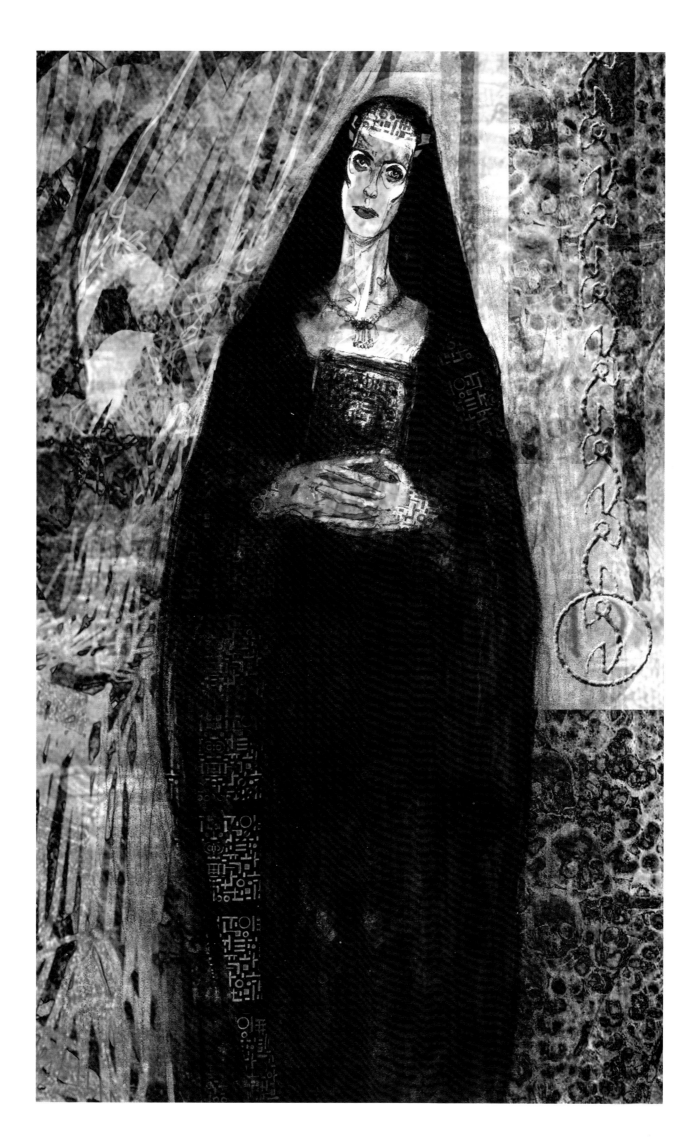

# How I work

The digital paintings in this book were created for book covers, computer games and as personal paintings. They represent five years of discovery and still ongoing digital exploration. All of these paintings were done in Photoshop. I like the software because it offers both photo manipulation and painting capabilities. At the beginning, my results were clumsy, as would be expected when learning any new tool. My methods were too mechanical and fragmented. It was all too easy to fall into the Photoshop traps of using photo references as rigid collages, and avoiding painting. Through trial and error I discovered that the best approach is to think traditionally.

Each painting starts from a scanned pencil or inked sketch. Most of the time the sketches are very loose. My first exploration is to establish the mood. At times, the subject will dictate the atmosphere, but I like the idea of not knowing right away and watching the mood reveal itself. Under the sketch I start layering references of various lights and colors that appeal to me. I find it better that these references are not connected to the subject. This process is not unlike the glazing technique used in oil or acrylic. I apply the first layer, "thinly" playing with different opacities, and then I start using the Photoshop arsenal to manipulate the reference, by blurring, distorting, etc. I repeat the process with a succession of different references on different layers until the foundation of the painting begins to take shape. From there I start painting broadly on a new set of layers to block the elements and to define the tonal values. At this stage I start seeing how the painting might come together.

The second exploration involves another pass of glazing and "scratching" using the erasing tool and painting, but this time it is to refine and start the detailing of the various elements. It will also define the style the painting might acquire, such as a "soft feel" where the photo element becomes a texture, or a more "aggressive and direct feel" involving broad strokes of painting and scratching. Nothing is ever set in stone; each painting is a surprise to me, as I learn new things and try others. Because of the layering system of Photoshop, I can always experiment and adapt to different needs without fear, and this has really improved my skill as a painter. In the end, the results are almost always better than anything I could have imagined.

# Awards

**Para 2** – 2004 spectrum gold award "comic book cover"

**Light** – 2004 expose' 2 master award "transportation"

**Angel City** – 2004 expose' 2 master award "environment"

**Hostile Takeover** – 2004 expose' 2 excellence award "character in action"

**Eden** – 1997 spectrum silver award "advertising"

Stephan Martiniere Contact Info:

Martiniere@neteze.com

To order additional copies of this book and
to view other books we offer, please visit:
www.designstudiopress.com

For volume purchases and resale inquiries
please e-mail:
Info@designstudiopress.com

Or you can write to:

Design Studio Press
8577 Higuera Street
Culver City, CA 90232

tel. 310.836.3116
fax 310.836.1136